IMAGES
of America

WINDSOR

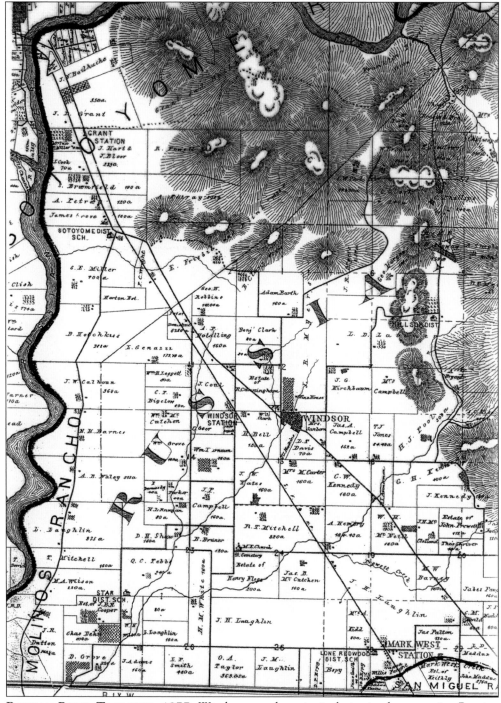

RUSSIAN RIVER TOWNSHIP, 1877. Windsor was the principal city in the extensive Russian River Township. (*Thompson's Illustrated Atlas of Sonoma County, 1877.*)

COVER: Henry Bell's Dry Goods Store, pictured *c.* 1891, carried all the necessities of life. Bell sold the store to William McCutcheon, who sold it to L.E. Packwood. (Windsor Historical Society.)

IMAGES
of America

WINDSOR

Barbara F. Ray

ARCADIA

Published by Arcadia Publishing
Charleston SC, Chicago IL, Portsmouth NH, San Francisco CA

Printed in Great Britain

Library of Congress Catalog Card Number: 2004104890

For all general information contact Arcadia Publishing at:
Telephone 843-853-2070
Fax 843-853-0044
E-mail sales@arcadiapublishing.com
For customer service and orders:
Toll-Free 1-888-313-2665

Visit us on the internet at http://www.arcadiapublishing.com

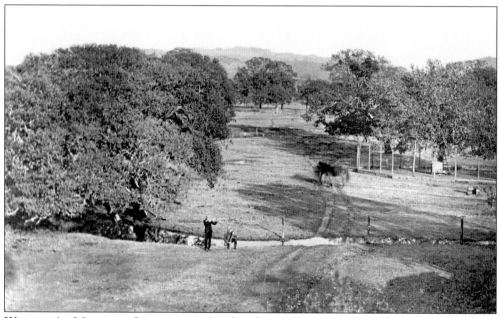

WINDSOR'S MAJESTIC LANDSCAPE. In this late 1800s scene on the Arata Ranch, a creek meanders lazily through a green pasture shaded by ancient oak trees, one of which provides shelter for chickens. In the foreground, hunters keep an eye out for game. (Arata family collection.)

CONTENTS

ACKNOWLEDGMENTS

I extend sincerest thanks to the following individuals and organizations without whose assistance this book would not have been possible. Their willingness to share their time and expertise is greatly appreciated.

Organizations that provided archival data, photographs, insights, and advice include the Windsor Historical Society, the Healdsburg Museum, the Sonoma County Library, and the Sonoma County Museum.

Individuals who shared family and community stories and photographs, helped identify individuals and locations in photographs, provided leads to other resources, critiqued book drafts, and enthusiastically supported and encouraged me in this work include my husband, Norm Ray, Windsor Historical Society president Stephen Lehmann, Healdsburg Museum research curator Holly Hoods, Don Arata, Candy Bailey, Angelo Bertozzi, John Bertozzi, Gary Blasi, Josephine Blasi, Alice Brooks, Marie Coakley, Leroy Danhausen, Irene DuVander, Jim DuVander, Lee Dysart, Gladys Engelke, Mary Frost, George Greeott, Sheila Haney, Ellery Hembree, George Hinkle, Richard Paul Hinkle, Edna Honsa, James Hotchkiss, Ellen Johnson, John Lewis, Lorraine Owen, Josephine Rebich, Elinor Rich, Jesse Shannon, Brandon Tynan, and, last but not least, my editor Hannah Clayborn.

I am deeply grateful to the numerous Windsor old-timers who shared their personal histories before leaving us for their family reunion in heaven; and I salute all those everywhere who collect memorabilia and contribute to genealogical and historical organizations for the benefit of future generations.

—Barbara F. Ray

INTRODUCTION

For thousands of years, Native Americans inhabited California, including present-day Sonoma County. Native American artifacts such as stone mortars and pestles and flint arrowheads have been found on Windsor ranches. Indians, likely the Pomo, gathered acorns from the area's oak trees and ground them into meal that, when cooked, might be served with a portion of meat from the hunter's kill.

Then, during the 1840s, American settlers from throughout the United States, lured by dazzling promises of gold and abundant land, their energies fueled by the flames of Manifest Destiny, moved by the thousands into California. Soon after, Europeans arrived, seeking a better life for themselves and their families. Some journeyed into unknown territory 50 miles north of San Francisco where they discovered breathtaking vistas, crystal clear rivers and creeks teeming with fish, abundant game, fields of wild oats as high as a horse, and majestic oak trees everywhere. According to local lore, one early settler, Hiram Lewis, thought the beautiful, oak-studded terrain resembled the landscape around Windsor Castle in England, so he christened the area "Windsor."

Records indicate that Windsor's 1840s settlers included Franklin Bedwell (1843), J.P. Smith (1847), the Levi Slusser family (1848), and others. Lindsay Carson, the brother of the famous Indian scout Kit Carson, built an adobe house in the Windsor area in 1847. Lindsay Carson also guarded the 100-wagon train that brought Lt. Col. James Prewett's family to California around 1849. James's son, John Prewett, became Windsor's first schoolteacher at Prewett School.

By 1855 Windsor was an official town with its own U.S. post office and the principal town of the Russian River Township that encompassed 41,423 acres. In its heyday, Windsor boasted four hotels, seven saloons, seven wineries, several grocery stores, three livery stables, a railroad depot, lodge halls, numerous grammar schools, and many other businesses. Farmers in the area raised livestock and grew grain, grapes, hops, and prunes in the rich Russian River bottomland. Herds of cattle were driven from area ranches through the streets of town to the train depot. During World War II, fighter planes roared overhead to the army air base constructed on Windsor ranchland, and on the other side of town, a prisoner-of-war camp housed young Germans who worked on Windsor's farms.

Through the years, Windsor has lost numerous historic structures to fire, but several buildings still stand, including the homes of Henry and Noah Bell, the old Methodist Church, the Masonic and IOOF Halls, and others. Two significant structures are protected by the Town of Windsor and the Windsor Historical Society—the c. 1860 landmark home of pioneer Robert Cunningham and the 1931 home of Dr. Atlas Hembree.

Noted celebrity Hazel Hotchkiss Wightman, a world-famous tennis player during the early 1900s, grew up on Windsor's Hotchkiss Ranch and attended Sotoyome School with her siblings. And in 1911, Fred Wiseman built and tested an airplane on the Laughlin Ranch, then flew the plane into record books by establishing the first airmail service in the world, delivering a letter from Petaluma to Santa Rosa.

On this pictorial journey into Windsor's little-known first 100 years, you will meet many of the individuals and families who built a unique and admirable community by virtue of their dreams for a better life, their intelligence, and their perseverance in the face of incredible obstacles. Along the way, they enjoyed simple pleasures and, most of all, their beloved families. With hearts and souls focused on family and community, the men and women of Windsor's first century left a rich legacy for future generations. Now, sit back, relax and enjoy this glimpse into Windsor's past. Our pioneers await!

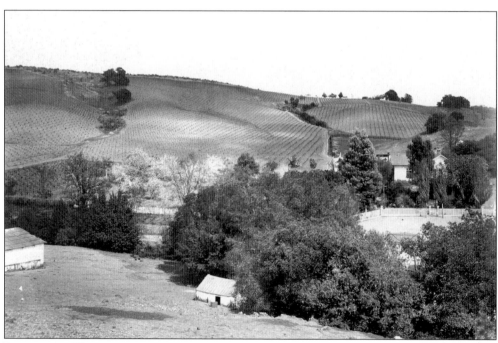

PANORAMIC WINDSOR FARM SCENE. Grapevines covered hundreds of acres in Windsor by the late 1800s. This picture was taken by C.L. Bell, a local female photographer who captured many Windsor scenes and people on film. (Windsor Historical Society.)

One
THE PIONEERS' DREAM
CALIFORNIA

Pioneers came by the hundreds of thousands across America's plains and from other countries, filled with boundless dreams and the courage and perseverance to make those dreams a reality. During Windsor's first 50 years, such men and women laid a solid foundation for future generations, and during the next 50 years they built upon that firm base. For most, golden California did not disappoint.

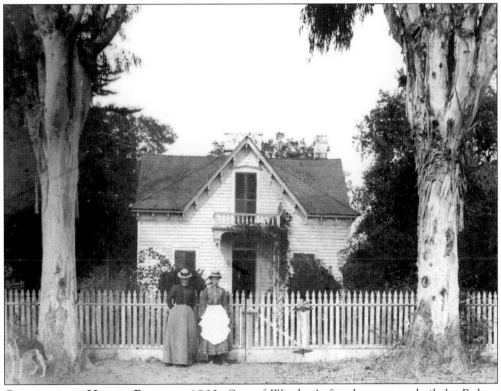

CUNNINGHAM HOUSE, BUILT C. 1860. One of Windsor's first houses was built by Robert Cunningham, who traveled via Cape Horn from Princeville, Illinois, to California in 1849. His wife, Isabella, and only daughter, 10-year-old Mary Jane, joined him in 1852, crossing the plains in a wagon train with Isabella driving one covered wagon pulled by oxen, while supervising another. The woman on the left is believed to be Mary Jane Cunningham. (Windsor Historical Society.)

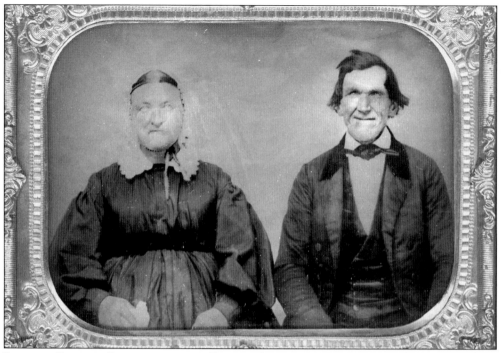

ISABELLA RUSSELL CUNNINGHAM AND ROBERT CUNNINGHAM, C. 1860. Robert Cunningham was born in Ireland in 1806, the same year Isabella Russell was born in Pennsylvania. Immediately upon settling in Russian River Township, Robert involved himself in local activities, donating land for community buildings and opening his corrals for cattle branding. Before the area was christened "Windsor," many called it "Cunningham's." (Frost family collection.)

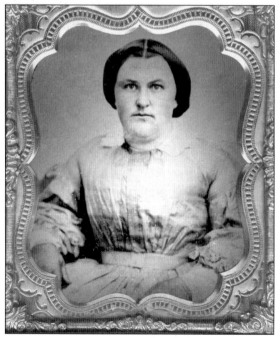

MARY JANE CUNNINGHAM, C. 1860. Mary Jane, who was born on June 22, 1842, in Henry County, Illinois, faced life's greatest hardships at an early age. She married John Cocke in 1857 when she was barely 15, gave birth to a son, Robert, in February 1859, endured the anguish of her baby's death in April, and became a widow in July when her husband passed away. A brighter future awaited, however, for in 1861 she married James McClelland with whom she had two daughters, Ella and Clara. (Frost family collection.)

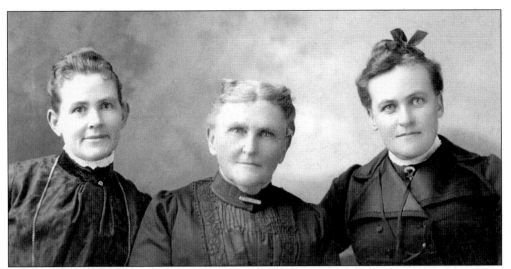

McCLELLAND WOMEN, C. 1910. Pictured are, from left to right, Ella McClelland Welch, Mary Jane Cunningham McClelland, and Clara McClelland Hembree. (Frost family collection.)

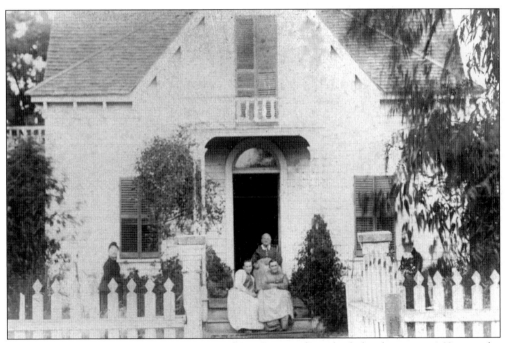

THE CUNNINGHAM HOUSE, C. 1889. Robert Cunningham built his home on 160 acres he purchased for $1.25 per acre. Much of West Windsor has been developed on land that once belonged to the Cunninghams. The women pictured above on the front porch are widow Isabella Cunningham seated behind her granddaughter Ella McClelland, on the left, and daughter Mary Jane Cunningham McClelland on the right. (Frost family collection.)

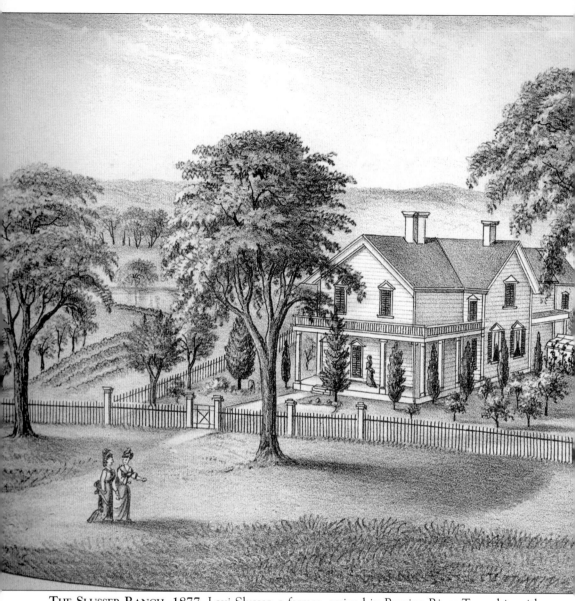

THE SLUSSER RANCH, 1877. Levi Slusser, a farmer, arrived in Russian River Township with his family in 1848 and by 1850 had purchased land and constructed a beautiful, spacious house on a road that would eventually bear the family surname. The two-story home was filled with fine furniture that had been shipped around Cape Horn, and the landscaping surrounding the house was well-kept. In the 1870 U.S. federal census, the Slusser family included Levi, his wife,

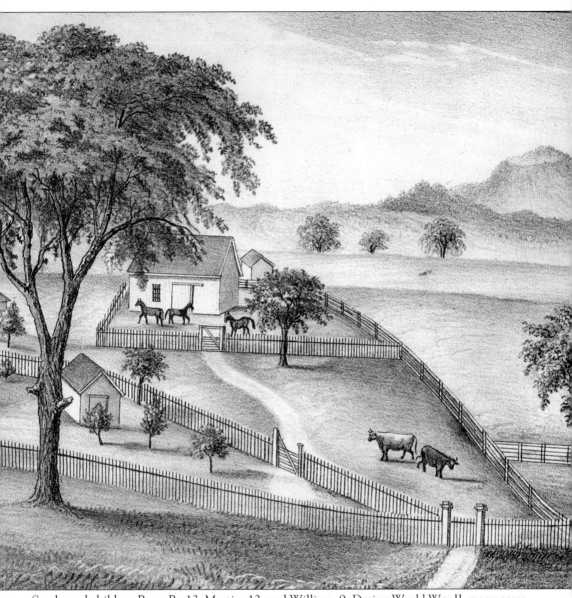

Sarah, and children Barra B., 13; Martin, 12; and William, 9. During World War II, many acres of the Slusser Ranch property were hastily appropriated by the government to build a military air field, now the location of Sonoma County Airport. (*Thompson's Illustrated Atlas of Sonoma County*, 1877.)

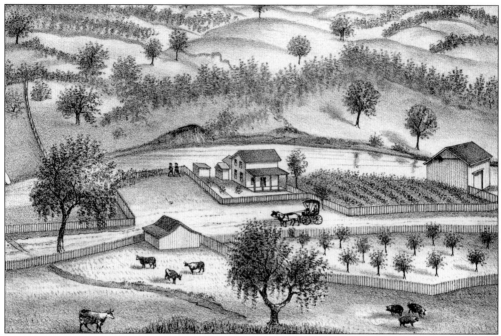

HOMESTEAD OF WIDOW MARY BEDWELL BROOKS, 1877. In 1851 James and Mary Brooks, who was a sister to Bear Flag Revolt participant Franklin Bedwell, homesteaded in the hills northeast of Windsor. The Brooks family celebrated the township's first marriage when Bettie Brooks married John Prewett in 1853. (*Thompson's Illustrated Atlas of Sonoma County, 1877.*)

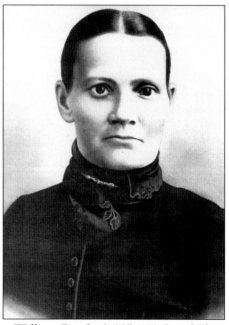

WILLIAM BROOKS AND ELIZA BUELL BROOKS. William Brooks (1837–1894) and Eliza Buell Brooks (1840–1910) had 11 children who attended Hill School, hiking over the steep hills from their home on Brooks Road to the schoolhouse on Chalk Hill Road.

14

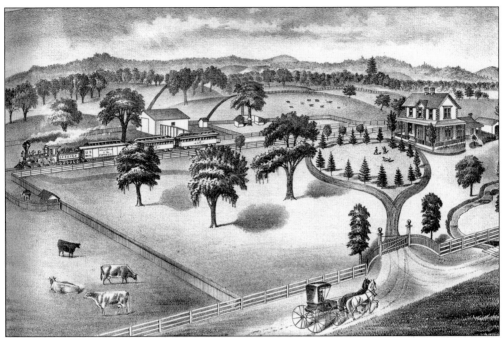

FRANCIS C. WRIGHT RESIDENCE, 1877. Changing times are evident in this scene that juxtaposes a horse-drawn carriage with a Northwestern Pacific locomotive. Train tracks were laid through Windsor in 1872, so the "iron horse" was still a new and fascinating experience. (*Thompson's Illustrated Atlas of Sonoma County, 1877.*)

KENNEDY HOUSE, PLEASANT AVENUE, BUILT C. 1875. Around 1920 when the Higby family owned this pioneer property, world-renowned horticulturist Luther Burbank was a frequent visitor. He had planted elephant plums and figs there and regularly rode his bicycle from Santa Rosa to evaluate the plants and visit with Earl Higby. Burbank usually arrived around noon and stayed for lunch, much to everyone's delight. (Blasi family collection.)

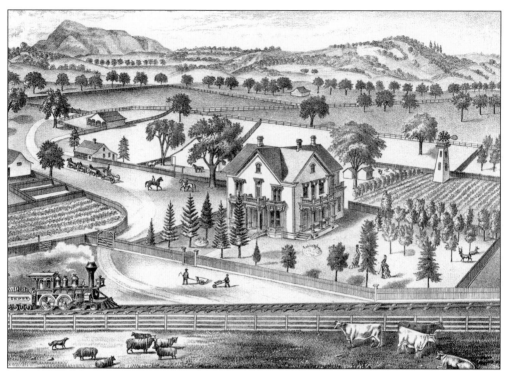

RESIDENCE OF JAMES H. LAUGHLIN, MARK WEST, 1877. Laughlin's ranch stretched from the main highway (present-day Old Redwood Highway) on the east to Windsor Road on the west, and his home and grounds, known as Shady Farm, were located at Mark West Station on the Northwestern Pacific Railroad. The oldest grave marker still legible in Shiloh Cemetery, dated October 14, 1850, is that of a Laughlin child less than a year old. (*Thompson's Illustrated Atlas of Sonoma County, 1877.*)

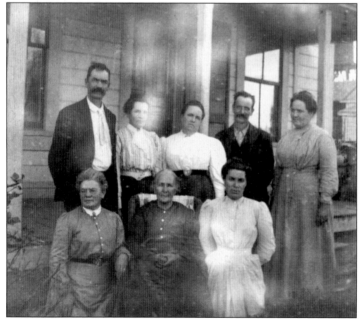

ROBBINS AND LAUGHLINS GATHER, C. 1900. Family members are, from left to right, (front row) Ella Laughlin, Grandma Young, and Annie Williamson; (back row) William Young, Lida Williams, Adah Robbins, Clarence Young, and Mertie Wilson. (Healdsburg Museum.)

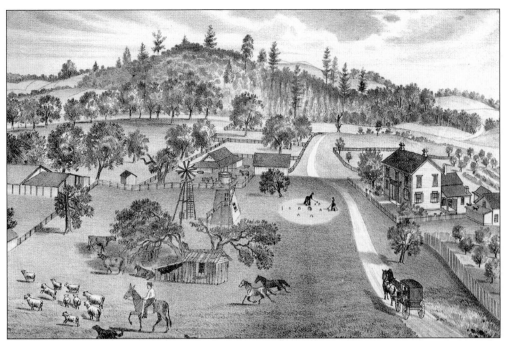

RESIDENCE OF FRANKLIN BEDWELL, RUSSIAN RIVER TOWNSHIP, 1877. Franklin Bedwell, born in Tennessee in 1810, was an adventurous soul, a mountain man who hunted and trapped throughout the western states. He was closely associated with Healdsburg's Cyrus Alexander and Kit Carson's brothers, Moses Carson, who worked for Alexander on his rancho, and Lindsay Carson, whose adobe was located near Eastside Road. Bedwell also participated in the Bear Flag Revolt of 1846. In 1858 Bedwell married Salina McMinn and spent the remainder of his life with her on his ranch. (*Thompson's Illustrated Atlas of Sonoma County*, 1877.)

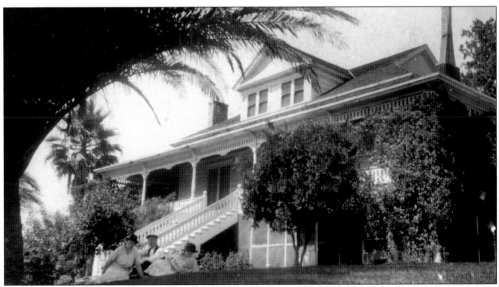

RAFORD PETERSON'S HOUSE ON THE WOHLER RANCH, 1922. Built as a summer home in the 1880s by Raford Peterson, this stately home was the central structure on the Wohler Ranch. Today it is a popular bed and breakfast. (Healdsburg Museum.)

17

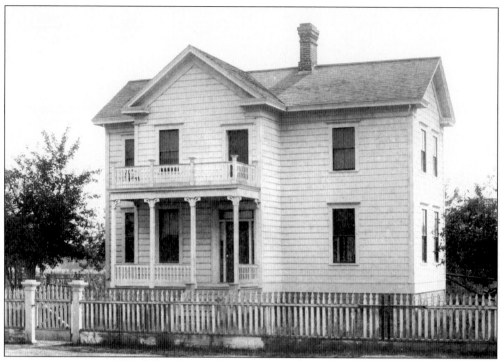

THE HENRY BELL HOME. Henry Bell arrived from New York around 1852. He was a skilled carpenter, farmer, merchant, and dairyman. He was also one of the area's first undertakers, using the lower floor of his River Road (now Windsor River Road) home as a funeral parlor. The Bell house still stands, a private residence, across the street from the historic 1890s Methodist Church. (Windsor Historical Society.)

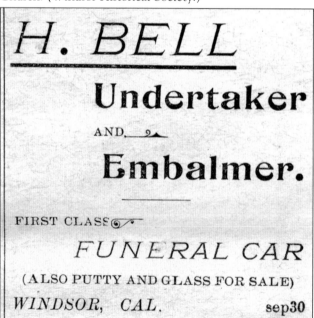

HENRY BELL NEWSPAPER ADVERTISEMENT, 1901. No space is wasted in this ad. Not only does Henry Bell promote his services as an undertaker, embalmer, and owner of a first-class funeral car, he also wants the community to know he sells putty and glass. Many pioneer carpenters doubled as undertakers because they were skilled at building coffins. (*Windsor Herald*, October 1901, Danhausen family collection.)

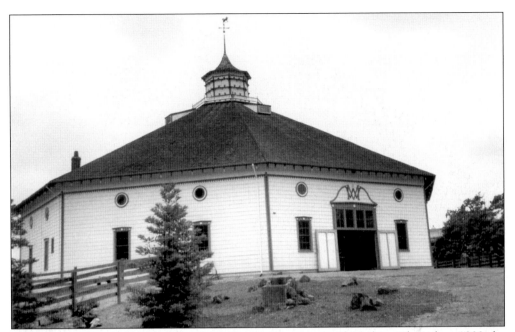

MT. WESKE ROUND BARN. This classic barn was constructed in the mid- to late 1800s by Gustav Adolph Weske, a wealthy San Franciscan with a passion for trotters and race horses. The octagonal barn, which was built of virgin heart redwood that was freighted on 16 train cars, had more than 50 horse stalls plus a two-room loft apartment with a fireplace, used by Mr. Weske on his visits to the ranch. From the barn's cupola, Mr. Weske watched his horses speed around the track that circled the building. (Engelke family collection.)

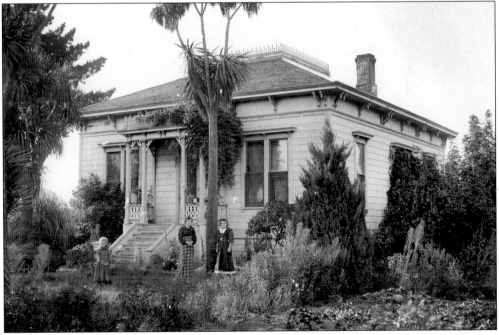

DAVE AND MABEL DUVANDER'S HOME, C. 1889. The home was located at 295 Windsor River Road. The women standing in front of the home are unidentified.

ARATA RANCH HOUSE, EARLY 1900S. Benito Arata bought the Windsor ranch in 1884, largely because this house had adequate room for his six children: August, Rosa, Louis, Celestina, John, and Katy. Shown in this picture are Sophie Arata, left, and Rosie Arata, right. This house still stands, although the covered porch and balcony have been replaced by tall posts that extend to the roof. Originally, the driveway in the foreground ran directly to downtown Windsor, but when the Highway 101 freeway was constructed during the 1960s, the Arata property was dissected and roads were realigned. Today the Arata house faces Los Amigos Road and has an abbreviated front yard. (Arata family collection.)

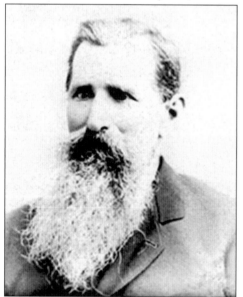
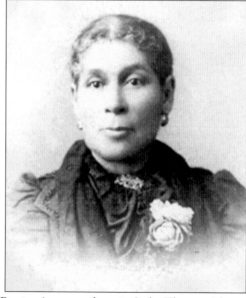

BENITO AND THERESA ARATA, EARLY 1900S. Benito Arata was born in Italy; Theresa Alviso, in Mexico. (Arata family collection.)

20

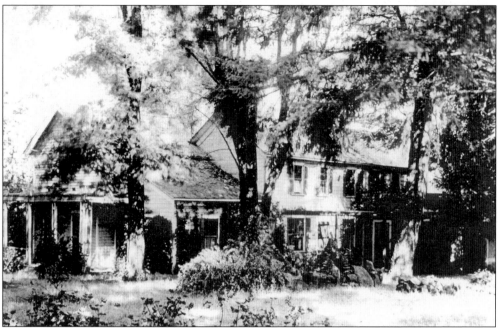

THE LATIMER HOME, C. 1870. A native of New York, Judge Lorenzo Dow Latimer and his wife, Sarah Myers Rich Latimer, lived in the Chalk Hill Road house shown above. As a federal judge, Latimer served in Sonoma County until his death in 1901. His son, Lorenzo Palmer Latimer, was a prominent and highly respected watercolorist, especially well known for his paintings of the Sierra Nevada Mountains. (Windsor Historical Society.)

YOUNG MAN AT WORK . . . OR PLAY, C. 1900. This photo was taken at the old Glenn Valley Springs property on Chalk Hill Road. The boy in the wagon is believed to be George Long. (Greeott family collection.)

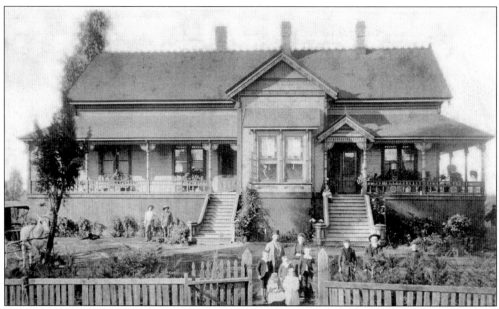

THE HOTCHKISS HOME, C. 1890. Shown above, three generations pose for an heirloom photo at the Hotchkiss home on Eastside Road. Family members are, from left to right, (front row) Hazel and Linville; (back row) W.J. (William Josephus) and Emma; (on the right side) Virginia, Benoni, and an unidentified person. Thirty years earlier in 1860, Benoni Hotchkiss with his wife, Virginia, and children had traveled by wagon train from Campbellsville, Kentucky, to Russian River Township where they settled on 375 acres of farmland. (Hotchkiss family collection.)

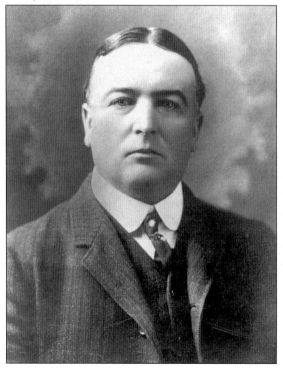

W.J. "JOE" HOTCHKISS. Joe Hotchkiss was an energetic entrepreneur who enjoyed success in many business ventures. He formed a partnership with his close friend James Miller, whose family owned the adjoining ranch, and together they developed prune packing and winery enterprises. Hotchkiss built several wineries, and he helped organize the California Wine Makers Corporation, becoming its general manager in 1894. He was also a major political force behind the building of the Golden Gate Bridge. Perhaps Joe's greatest claim to fame, however, is his daughter Hazel, who grew up to be the world-renowned tennis player, Hazel Hotchkiss Wightman, during the early 1900s. (Hotchkiss family collection.)

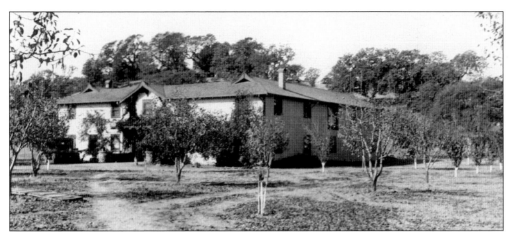

European-Style Barn, Greeott Ranch, 1939. In 1928, John Greeott bought what had originally been the Latimer Ranch on Chalk Hill Road. The main residence at that time was the spacious structure shown above. In traditional European fashion, the bottom floor was a barn and workshop, and the top floor was the family residence and hayloft. (Greeott family collection.)

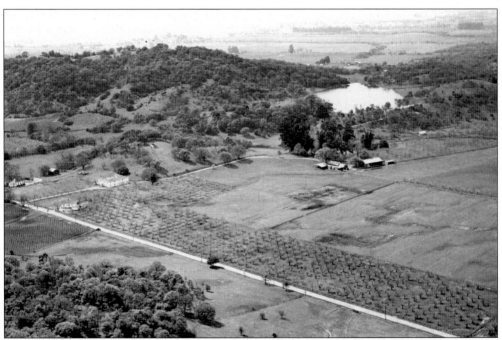

Greeott Ranch, c. 1959. George Greeott purchased the family ranch from his father in 1950 and continued to make improvements to the property, which included the construction of several lakes. This aerial photo of the Greeott Ranch was taken around 1959 and shows George's first lake, now an element of Foothills Regional Park. In the distance, the Windsor plain is visible. The European-style barn and long stretch of orchard along Chalk Hill Road occupy the left foreground. (Greeott family collection.)

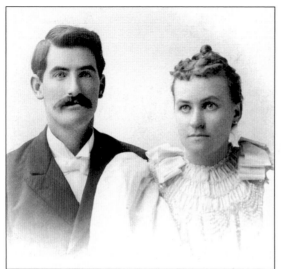

ATLAS AND CLARA MCCLELLAND HEMBREE. Two prominent families merged when Atlas and Clara wed in 1895. (Frost family collection.)

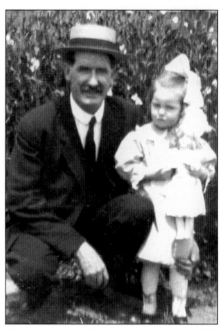

FATHER AND DAUGHTER, C. 1908. Atlas Hembree delighted in his daughter Georgia. (Frost family collection.)

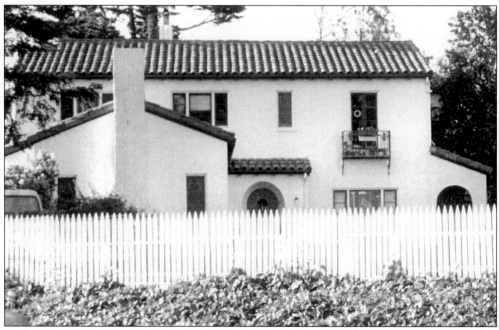

THE HEMBREE HOUSE. This Spanish-style home was built around 1931 by Dr. Atlas Hembree, a Windsor son who retired here with his wife, Clara McClelland Hembree, after enjoying a successful medical practice in Redondo Beach, California. An innovative man ahead of his time, Hembree installed underground power lines into the house. (Windsor Historical Society.)

Two

THE PEOPLE WHO
BUILT WINDSOR

Some of those who called Windsor home achieved worldwide fame and fortune, others were recognized as significant individuals within the community, and a few quietly lived their lives in near obscurity. But whatever their social status, people depended upon one another to satisfy life's basic needs and build the community, and therein lay their strength.

ELIZABETH FRYER HIGBY, C. 1910. Miss Fryer, as the woman in this photograph was familiarly known in the community, taught classical piano to numerous Windsor children during her lifetime. In 1930, at the age of 48, Elizabeth married Earl Higby and lived with him on his 85-acre Pleasant Avenue ranch. (Windsor Historical Society.)

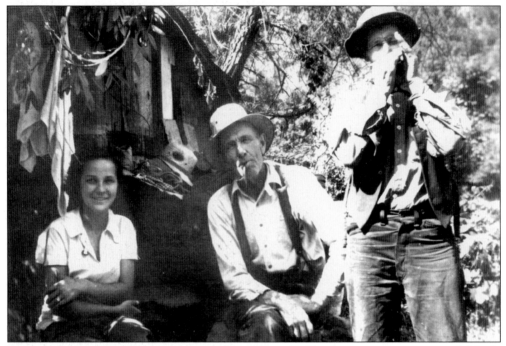

CHARLIE DUVANDER'S CABIN. Pictured above, Irene DuVander is enjoying a visit with Uncle Charlie DuVander while a man named Stone plays a harmonica at Charlie's cabin at Pine Log, Mendocino County, May 12, 1936. Charlie DuVander was a train engineer who in 1908 bravely rescued the citizens of Luffenholtz, California, during a raging forest fire that razed the town. (DuVander family collection.)

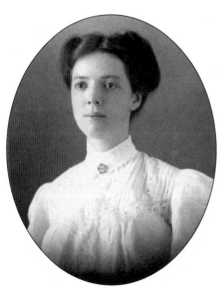

LAURA ELSBREE, c. 1900. Like most women during that era, nurse Laura Elsbree abandoned her career when she married George DuVander and concentrated on being a wife and mother. (DuVander family collection.)

KATE AND LOUIS HORVATH, C. 1900.
America was a land of opportunity for
immigrants worldwide. This photograph
of Irene Horvath DuVander's parents
was taken shortly before they set sail
from Hungary to the United States.
At the time of this photo, Mrs. Horvath
had already given birth to five of
her ten children. (DuVander
family collection.)

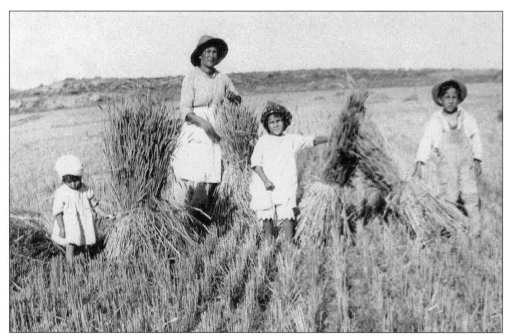

HARVESTING WHEAT IN MONTANA. Before moving to Windsor in 1921, the Horvath family
lived in Montana. Family members are, from left to right, Margaret, Kate, Irene, and Frank.
(DuVander family collection.)

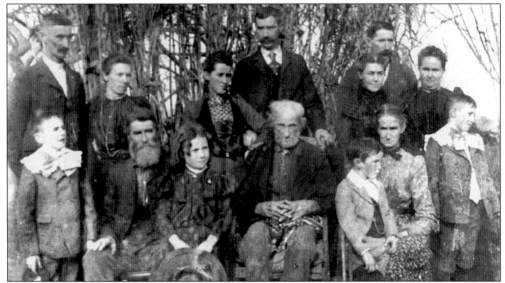

THE McCUTCHEON FAMILY, 1886. Two lines of the McCutcheon family settled in Windsor, the J.B. McCutcheons in 1863 and the W.C. McCutcheons in 1864. Family members shown above are, from left to right, (front row) Fred McCutcheon, William Charles McCutcheon, Mary Agnes McCutcheon, James Bell McCutcheon, William Alfred McCutcheon, Mary Jane Leggett McCutcheon, and Frank McCutcheon; (back row) George McCutcheon, Mary Meeks McCutcheon, Ada Ward McCutcheon, William Hugh McCutcheon, Jim McCutcheon, and Jenn Bell McCutcheon. (McCutchan family collection.)

SCHOOLMARM MATTIE WASHBURN, C. 1900. One of five children born to Faye and Fannie Washburn, Mattie grew up in a fun-loving family in East Windsor. Her siblings included Faye Jr., Earnest, Bertha, and Vernie. Mattie became a schoolteacher who taught children for 47 years, eventually teaching the grandchildren of former pupils. She was reputedly a rather stern woman, but students learned their lessons and many grew to love her. Mattie Washburn Elementary School on Pleasant Avenue was named in her honor. (Windsor Historical Society.)

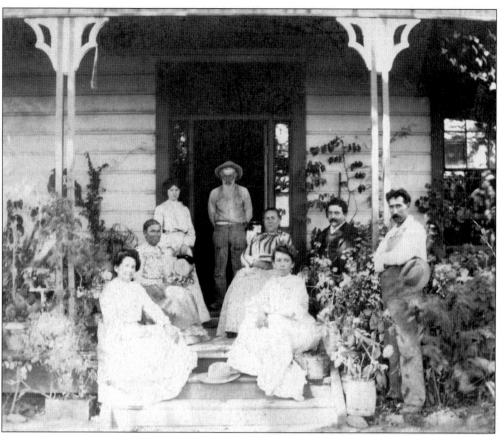

A QUIET AFTERNOON AT THE ARATA RANCH. Shown seated on the front porch of Benito and Theresa Arata's home are, from left to right, unidentified, Theresa Alviso Arata, unidentified, Benito Arata, unidentified, unidentified, Rose Arata, and Louis Arata. (Arata family collection.)

MRS. GEORGE A. NALLEY, EARLY 1900S. The serene lady pictured here is believed to be Alice Marion Nalley. The Nalley family owned a large ranch in the area of Eastside Road, where Alex B. Nalley, his wife, Martha, and son George were living in 1880. (Windsor Historical Society.)

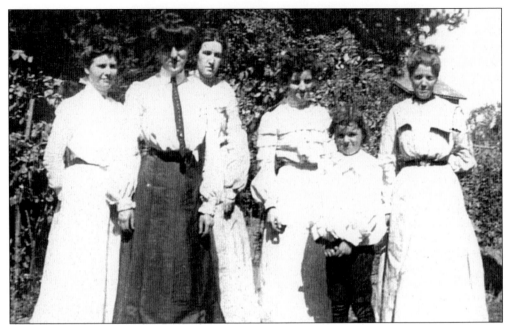

THE WASHBURN FAMILY. Family members are, from left to right, Mattie, Ina, unidentified, Vernie, Ross Pool (Bertha's son), and Bertha. A photo album notation reads: "The Sonomans are rapidly becoming civilized. In this group . . . two are able to play the piano, one is a student in the native school at Berkely [sic], one a teacher in the village school, and one the wife of a rich merchant." Of the five Washburn children, Faye Jr. left home early in life; Ernest taught school briefly then worked for Swift and Company; Bertha taught school until she married Frank J. Pool; Vernie was a bookkeeper for Frank Pool; and Mattie taught school. (Windsor Historical Society.)

PLEASANT AVENUE COWGIRLS, 1936. Diamantini sisters Josephine, left, and Sterina, right, were just pretending to be rifle-totin' cowgirls; neither girl ever learned to shoot a gun. In the Diamantini family, daughters helped with house and garden chores, leaving heavier ranch work and hunting to the men. (Blasi family collection.)

MR. AND MRS. EDWIN RICHARDS, 1916. Edwin "Dick" Richards lived a true boy-makes-good success story. Born in Wales in 1870 to a poor family, he was forced to leave home at 12 and fend for himself. He took any job available, hoarded every spare penny, and finally saved enough for a steamer ticket to America. In California and Alaska he mined gold and made several fortunes, some of which he lost to bank failures. But he continued to prosper, built a beautiful home in Wales for his mother, and in 1911 bought the ranch of his dreams in Windsor. Bessie Davies and Dick Richards were wed in 1916 and reared two children, Berwyn and Gladys, on their Brooks Road ranch. (Engelke family collection.)

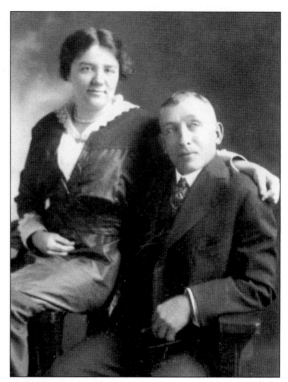

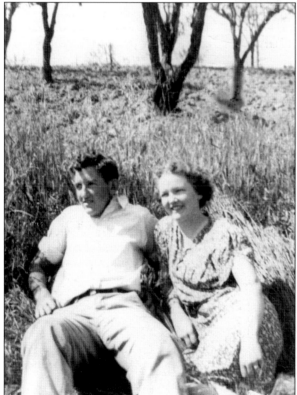

EASTER SUNDAY, 1939. On a Mt. Weske hillside, siblings Berwyn and Gladys Richards take a break from family activities. Frequently, numerous friends and relatives from San Francisco visited the ranch to enjoy the Richards's generous hospitality and the grandeur of Adolph Weske's round barn. Sometimes the parties were so large the city folk arrived in a chartered Greyhound bus. The Richards routinely decorated the basement, set up long tables, and barbecued meat for guests. (Engelke family collection.)

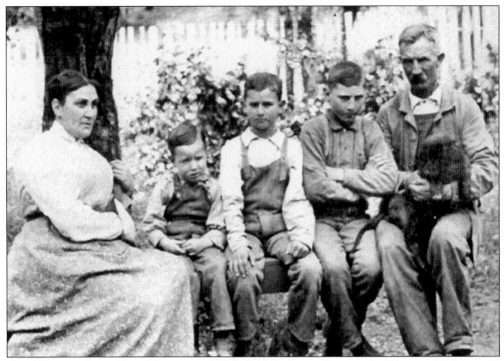

THE WILLIAM BURR RICH FAMILY, C. 1900. In this classic photograph, Clarence Rich, age 13 or 14, gives mute evidence that petulant teenagers are not unique to modern society. Rich family members are, from left to right, Ella Faught Rich, Edwin Rich, Stewart Rich, Clarence Rich, and William Burr Rich. (Windsor Historical Society.)

THE SHRINER AND HIS STAR. Shown here, shriner Joe Wright escorts Cora Gutshall, a member of the Order of the Eastern Star, at a meeting in the Masonic Lodge Hall around 1950. Cora was a well-known voice in Windsor for many years as the operator for the telephone switchboard. (Rebich family collection.)

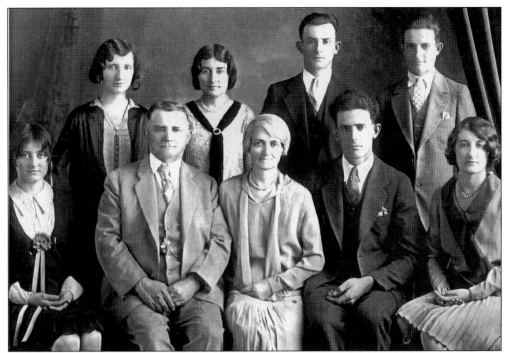

THE JOHN GREEOTT FAMILY, 1928. This photograph was taken the year John Greeott bought what once had been the Latimer Ranch on Chalk Hill Road. Only four of the children moved to the ranch—John Jr., George, Wesley, and Theresa—and of those, only George remained permanently, buying the ranch for his own family in 1950. Family members are, from left to right, (front row) Theresa, parents John and Sarah (née Williams), John Jr., and Isobel; (back row) Virginia, Julia, Wesley, and George. (Greeott family collection.)

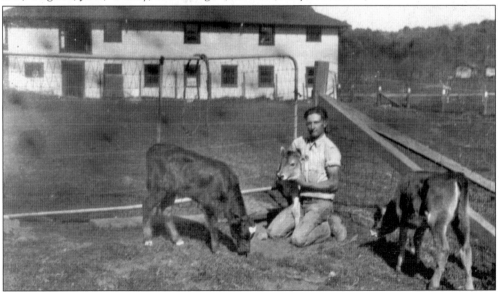

GEORGE GREEOTT, 1932. With calves he was raising for his father, George knelt in front of the European-style barn that was built by Edward and Myrtle O'Brien around 1918. (Greeott family collection.)

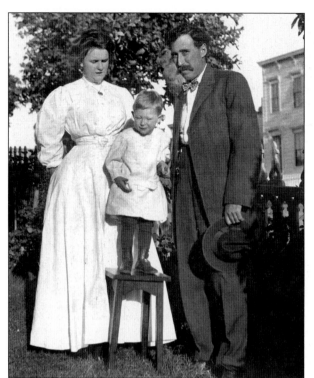

PROUD PARENTS, C. 1910.
While living in Vallejo, Louis and Sophia Arata posed for a snapshot with their only son, Stanley, who was not yet old enough to wear long pants. Young boys generally wore dresses until they were potty-trained, which made it easier to change diapers. (Many wore dresses even longer.) However, unlike most boys of the era who would have had long curls at his age, Stanley's hair was cut in a manly style. (Arata family collection.)

KATE VISITS THE RANCH, C. 1930.
Throughout Theresa Arata's lifetime, the ranch was a favorite gathering place for members of her large, extended family. Pictured with her here are son Louis and daughter Catherine. Catherine, or "Kate" as she was affectionately known, never married. Instead, she enjoyed a successful career as a woodworker, a member of the Furniture Workers' Union. In 1914 she single-handedly planned and constructed a five-room bungalow on the Arata Ranch, and she also built a large barn there. In 1917 she took a job as a cabinet maker in San Francisco, where she worked for more than 20 years. (Arata family collection.)

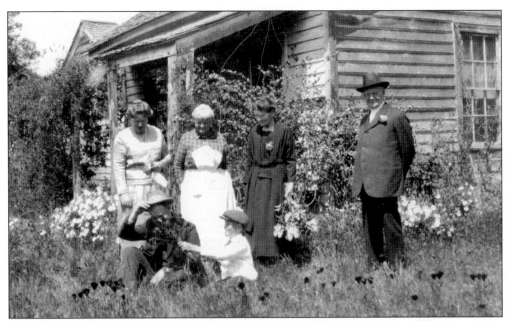

SWEET ELLA WALK, APRIL 1922. Ella Walk, an aunt of Mattie and Vernie Washburn, was loved by all. In this snapshot she stands in front of her small Windsor home. The boy is Jasper J. Walk. People standing are, from left to right, Annie Walk, Ella Walk, Aunt Mary Frances, and a man named McMelvin. The man seated on the grass is not identified. (Windsor Historical Society.)

ROLLO "ROLLY" JONES, C. 1950. Rolly Jones was the grand master of the Windsor Grange at its first meeting in the new Grange Hall on Starr Road on June 22, 1942. (Rebich family collection.)

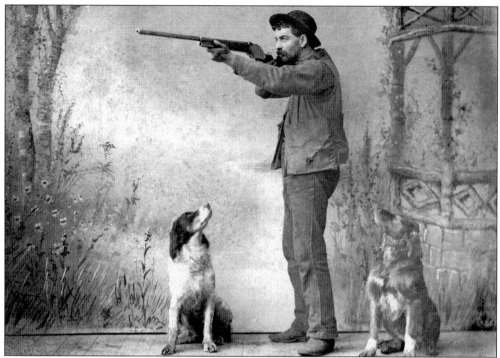

CONSTABLE SHANE, C. 1900. In Windsor's early history, law enforcement was the responsibility of a constable, usually a local citizen, who was a peace officer with less authority and a smaller jurisdiction than a sheriff. In this studio portrait, Constable Shane poses bravely with his trusty rifle and faithful dogs. (Windsor Historical Society.)

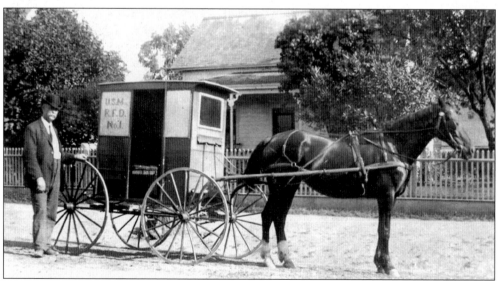

RURAL FREE DELIVERY, ROUTE 1. In 1905, RFD was established in Windsor and covered an area of six square miles. The service brought not only mail but magazines and catalogs to rural homes. Postmaster W.C. Lindsay advertised for a carrier to be paid $540 a year, "which covered everything, including horse hire." (Windsor Historical Society.)

Three

WINDSOR

EAST AND WEST

Windsor's first commercial center emerged on the east side of the main road between Healdsburg and Santa Rosa. By 1860 there were homes, a school, a church, a hotel, and other businesses along the thoroughfare. Then everything changed in 1872 when railroad tracks slithered through west of town. Heated arguments soon arose between traditionalists who wanted to maintain the town's business center on the east side and forward thinkers who envisioned greater commercial benefits near the train depot. Their differences of opinion and unyielding determination were divisive, and as the town shifted west, the community split into East Windsor and West Windsor. It would be many years before the wounds of separation healed and the community reunited.

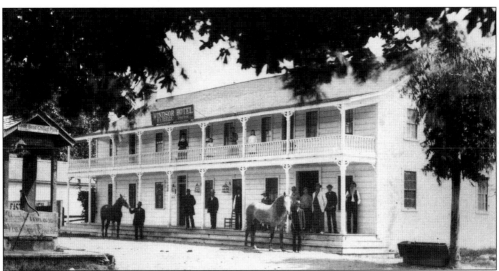

THE WINDSOR HOTEL. In 1856, Sevier Lewis opened the first hotel in Windsor, also called a retreat, located on the main road between Healdsburg and Santa Rosa in what is currently the east side of town. A community well sat in the middle of the street near the hotel so thirsty travelers could refresh themselves. In 1858, Samuel Emmerson, who was the primary mover in laying out the town that year, was proprietor of Windsor Hotel. The wood-frame establishment burned in 1911 and was not rebuilt.(Windsor Historical Society.)

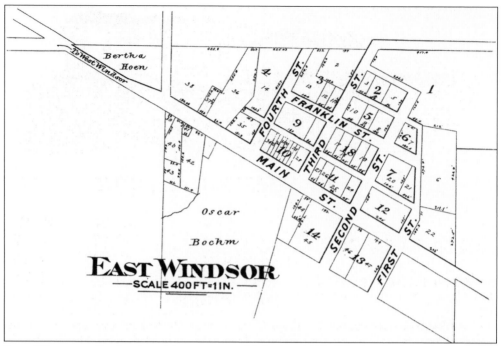

EAST WINDSOR. By the time this map was published in 1898, Windsor had divided into East and West. (*Illustrated Atlas of Sonoma County, 1898.*)

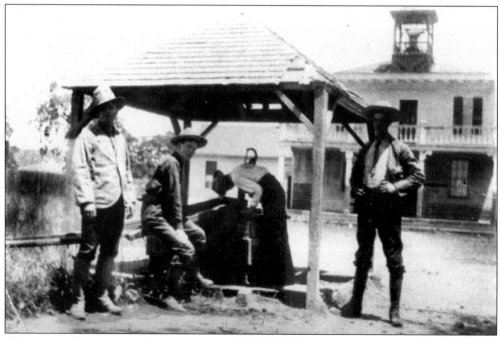

WINDSOR'S COMMUNITY WELL, C. 1880. Shown above, one man pumps water while three others wait their turn. In the background Windsor's grammar school is visible, across the street from the Windsor Hotel. (Windsor Historical Society.)

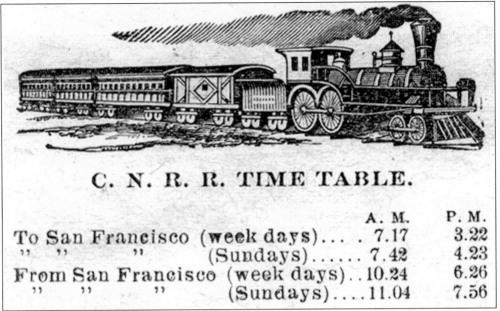

C. N. R. R. TIME TABLE.

	A. M.	P. M.
To San Francisco (week days)....	7.17	3.22
" " " (Sundays)......	7.42	4.23
From San Francisco (week days)..	10.24	6.26
" " " (Sundays)....	11.04	7.56

CALIFORNIA NORTHWESTERN RAILROAD TIME TABLE, 1901. For many years and many people, the arrival of the train was the most important event of the day. The Smith girls, daughters of Ira Smith, the East Windsor blacksmith, delighted in dressing up and walking to the depot to greet incoming trains. One Windsor old-timer, who had worked for the railroad and had received a railroad watch, regularly met the trains to confirm that they arrived on time. (*Windsor Herald*, October 1901, Danhausen family collection.)

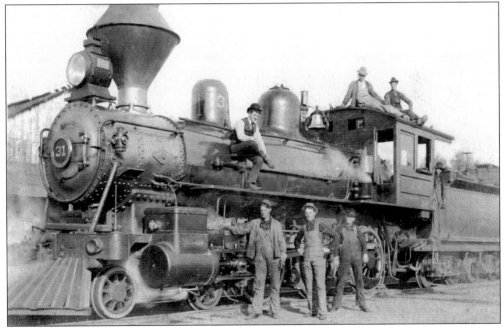

THE MIGHTY CNRR. The crew of the train 33 & 34 CNRR included J. Haley, conductor; B. Pohley, engineer; J. Storey, tab.; F. Lyall, caboose; D. Gallagher, head; B. Bosworth, rustler; E. Duggan, fireman. (Windsor Historical Society.)

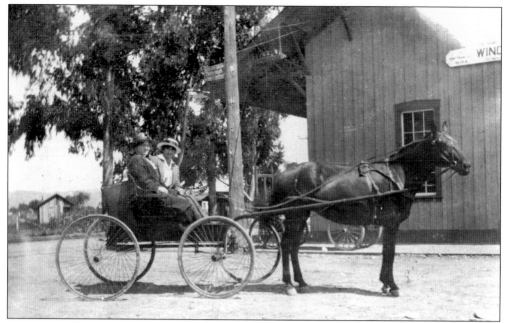

WAITING FOR THE TRAIN, C. 1880. An outing to Windsor's depot to watch the train arrive was a pleasant activity. There was some risk, however, that the dragonlike monster might frighten an unsuspecting horse. (Windsor Historical Society.)

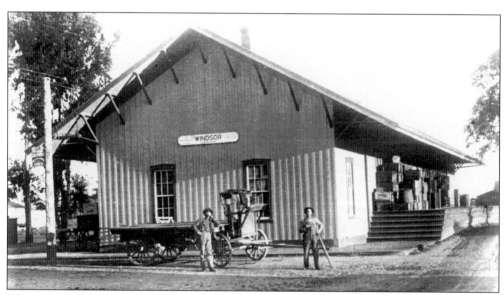

WINDSOR TRAIN DEPOT, C. 1940. Long ago products for local stores came by rail from San Francisco. The stationmaster would roll a four-wheeled truck out to the edge of the tracks, and deliveries would be unloaded by the train crew and station agent. (Windsor Historical Society.)

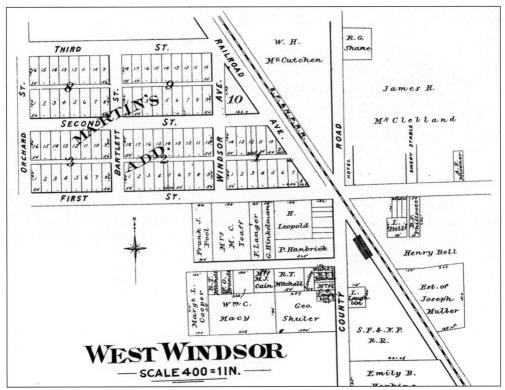

WEST WINDSOR. By 1898, West Windsor was rapidly becoming the hub of community activity. (*Illustrated Atlas of Sonoma County, 1898.*)

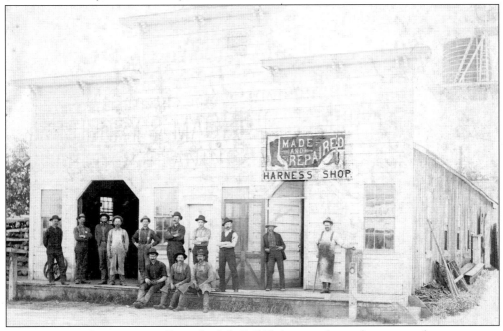

THE HARNESS SHOP, 1880S. From the left, Jeff Philpott is the sixth man standing, wearing a derby hat. (Windsor Historical Society.)

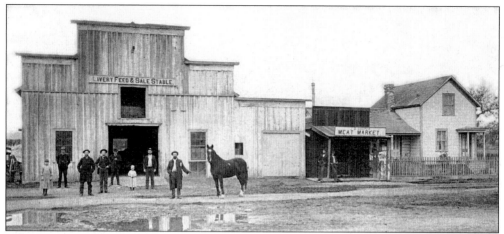

LIVERY STABLE AND MEAT MARKET, C. 1890. In the days when transportation was horse powered, downtown livery stables thrived. They rented and sold horses, feed, and a variety of horse-drawn vehicles. In 1908 J.C. "Toots" Martin had a butcher shop at the Emery Brothers Livery Stable. Customers walked into the livery stable, up two steps through a door into the meat market. (Windsor Historical Society.)

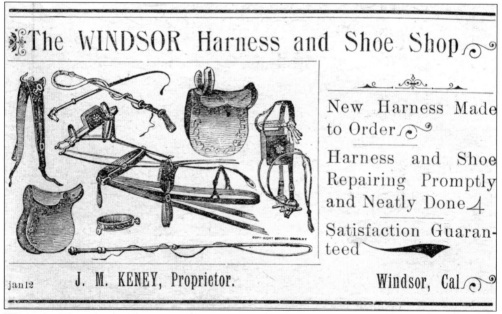

WINDSOR HARNESS AND SHOE SHOP ADVERTISEMENT, 1901. Before automobiles replaced the horse and carriage, harness shops were essential businesses. Shoe repair was a natural sideline for those skilled in working with leather. (*Windsor Herald*, October 1901, Danhausen family collection.)

WELCOME TO JEFF PHILPOTT'S SHOP. During the early 1900s, stores like this one served rural Americans. Jeff Philpott is on the left wearing a hat. (Windsor Historical Society.)

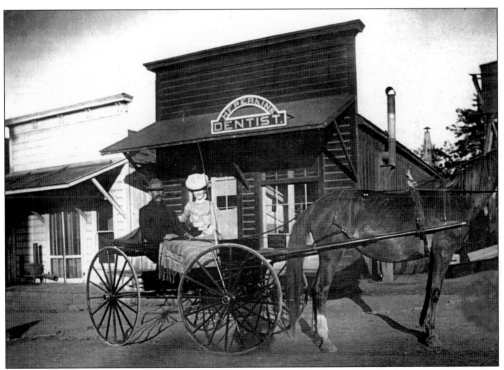

DENTAL OFFICE OF H.E. PERKINS, C. 1900. This couple, dressed up and cozy in a warm lap robe, may be out for a Sunday drive or perhaps they have a connection to the new dental office. (Windsor Historical Society.)

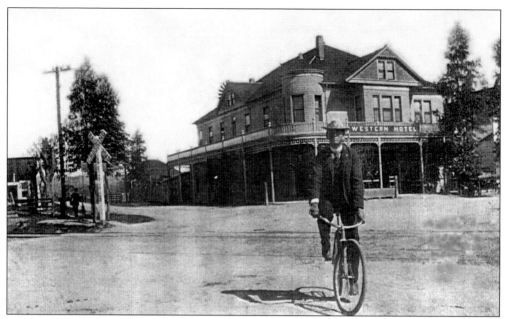

THE WELL-DRESSED CYCLIST, C. 1900. In this photograph Arthur Brooks is riding his bicycle down Windsor Road in front of the Western Hotel, which was located at the northeast corner of Windsor Road and Windsor River Road. (Windsor Historical Society.)

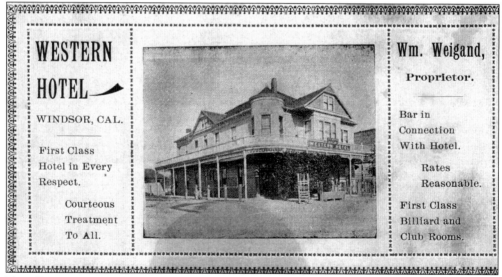

THE BEAUTIFUL WESTERN HOTEL. This broadside promoting Windsor's nicest hotel was probably handed out to businessmen and visitors. (Windsor Historical Society.)

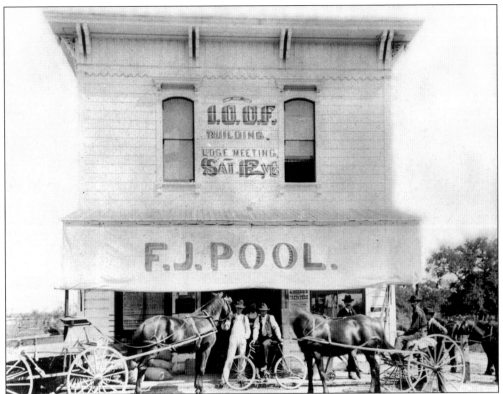

FRANK J. POOL'S STORE AND IOOF LODGE HALL, C. 1900. A respected citizen and businessman, Frank Pool was instrumental in establishing the first branch of the Exchange Bank in Windsor in 1925. (Windsor Historical Society.)

EAST WINDSOR, C. 1910. Graham's store is on the left. The well that was so appreciated by thirsty travelers in the 1850s is still visible 60 years later near the middle of the street in the distance. The Windsor Hotel, which burned in 1911, was across from and south of Graham's store. (Windsor Historical Society.)

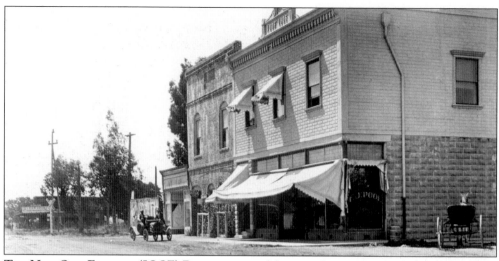

THE NEW ODD FELLOWS (IOOF) BUILDING AND MASONIC LODGE HALL, LATE 1920S. Most of Windsor's original structures were constructed of wood, which made them vulnerable to fires. During the 1800s and until 1905, the Osceola Odd Fellows (IOOF) (center) and Masonic Lodges owned buildings in West Windsor. The Masonic Lodge (right), rented its lower floor to Frank J. Pool for his general merchandise store. Then in 1905, a fire devastated much of the town, including the lodge halls. A year later, the great earthquake of 1906 resulted in additional structural failure and fire. By the late 1920s, new lodge halls had been constructed, but a 1932 conflagration once again destroyed them. (Windsor Historical Society.)

POHLEY'S LINIMENT. (*Windsor Herald*, January 1900.)

BARBER SHOP. (*Windsor Herald*, January 1900.)

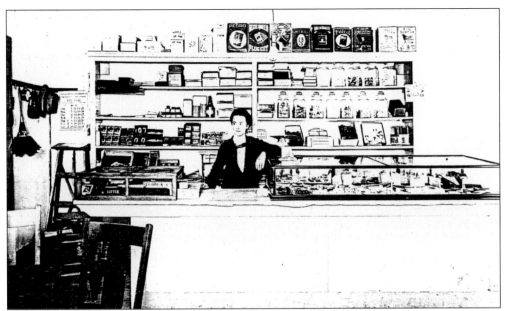

"Baldy" Morton's Store, Early 1900s. This general merchandise store was located on West Windsor's main street. "Lizzie" Pohley, the clerk shown in this photograph, later bought the store. (Windsor Historical Society.)

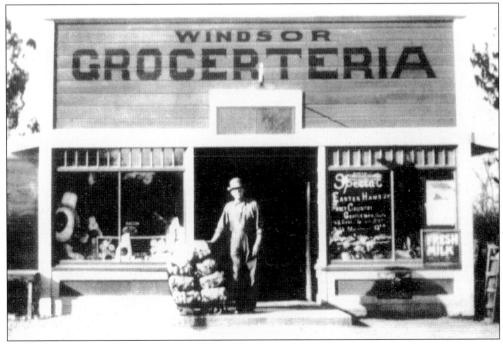

Windsor Grocerteria, Late 1930s. Al McCracken's grocery store was located on the southwest corner of Bell Street and Windsor River Road. (Windsor Historical Society.)

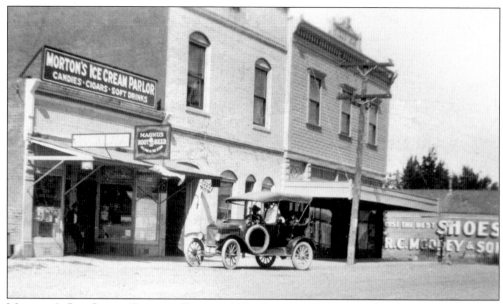

MORTON'S ICE CREAM PARLOR, EARLY 1920S. Ice cream was a popular American treat long before Windsor was settled. At some point the ice cream shop pictured above was also owned by the Endicotts, and other local businesses also sold the frozen treat. The business to the right with the awning in front is Pool's Grocery Store, situated on the corner of Bell Street and (Windsor) River Road, across from McCracken's Grocerteria. (DuVander family collection.)

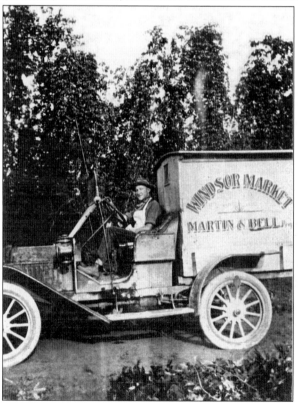

"TOOTS" MARTIN, 1930S. During the 1920s and 1930s, C.J. Martin owned a retail meat market on Windsor River Road, stocked with fresh cuts from his slaughterhouse on Windsor Road. He also delivered door-to-door and even to hop fields, first using a horse-drawn wagon and, later, a motorized truck. C.J. always tooted a horn to announce his arrival and usually gave free "weenies" to eagerly awaiting children. (Windsor Historical Society.)

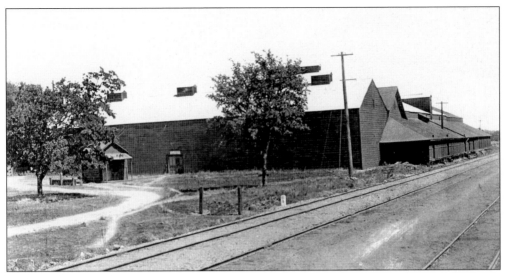

WINDSOR-TRENTON WINERY, C. 1880. Windsor's vineyards supported seven wineries. Shown above is what was the largest winery in Windsor, owned by business partners J. Miller and W.J. Hotchkiss. It was torn down during the early 1900s. (Windsor Historical Society.)

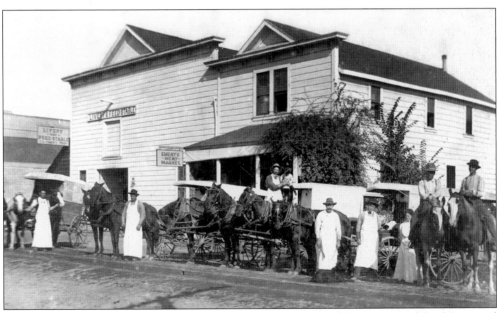

DELIVERY WAGONS, C. 1890. The employees of F.P. Swett's Stable, Livery, and Feed Store and F.A. Emery's Meat Market proudly display the tools of their trade. On the left is a very young C.J. "Toots" Martin with his isinglass-windowed meat wagon. (Windsor Historical Society.)

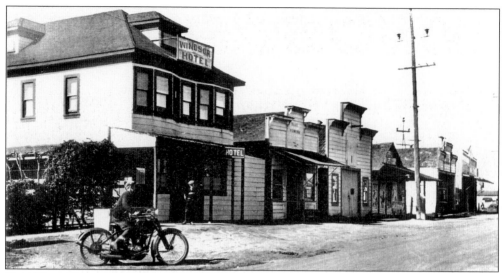

The New Windsor Hotel, c. 1918. The hotel shown above was built between 1912 and 1915, one of many businesses located on Windsor Road between Windsor River Road and Wahl Street. (Windsor Historical Society.)

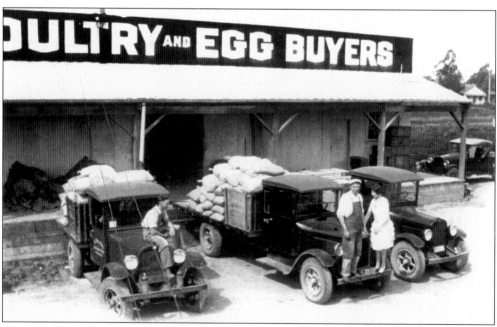

Windsor Feed and Supply Store, 1930s. Years ago, the feed store in West Windsor was one of the community's most important businesses. Many ranchers raised herds of cattle, sheep and other livestock, and even families in town raised chickens, ducks, and rabbits in their backyards for personal use. All depended on the feed store to meet their needs. For instance, during the 1920s and into the early 1930s when chickens were big business, chicken ranchers could buy everything they needed: food, grit, shells, litter, and even fluffy little chicks. (Windsor Historical Society.)

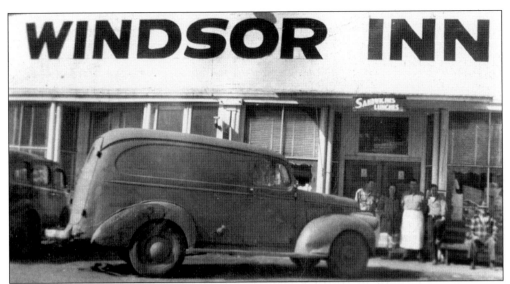

WINDSOR INN, MID-1940S. This inn was managed by brothers Del and Les Rousann, who, in addition to the usual barroom fare, installed an ice cream freezer and closed the bar during afternoons so youngsters could enjoy sweets and play pool. Les is on the left next to Del's wife, Pearl, and Del is wearing the apron. (Windsor Historical Society.)

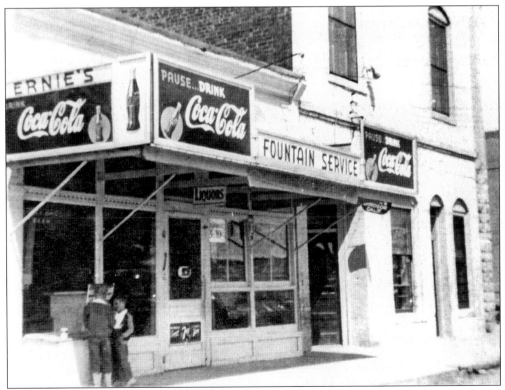

THE SODA SHOP, C. 1942. Ernie's Fountain was owned by Ernie Bertolone, and the smaller of the two boys standing in front of the soda shop is five-year-old Larry Bertolone. (Windsor Historical Society.)

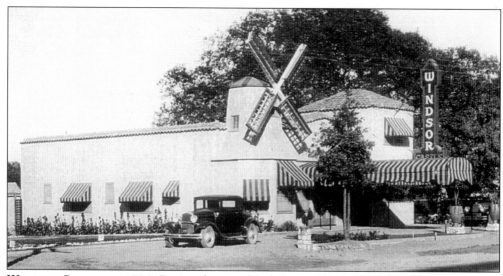

WINDSOR CASTLE, C. 1930. During the era of Prohibition (1919–1933) bootlegging became a way of life for more than a few Windsor citizens. One entrepreneurial group, who had acquired some fast cash selling "hooch" and believed Prohibition would soon fade into history, built this roadhouse on the main highway between Healdsburg and Santa Rosa. The building's design was eclectic: a two-story frame stucco structure in Spanish-style architecture with a Dutch windmill on the front. It was financed principally by an Italian, built by a local American contractor, painted by a Swede, had a French cook, a German bartender, and was given an English name, Windsor Castle. (Windsor Historical Society.)

DANCING THE POUNDS OFF, 1926. Thin was in during the Roaring Twenties. Jazz and the Charleston were all the rage, but slow dancing, shown in this advertisement, was popular, too. Not surprisingly, in addition to dancing, the ad touts a nutritional diet aid. (Author's collection.)

Four
FRONTIER FAITH

American pioneers were people of faith, and when settling a new area they built churches where they could praise God for His blessings, gather together to love and support one another in times of celebration and sorrow, and serve the community through charitable programs and social events. For many, many years, there was only one church in Windsor to meet the needs of the community.

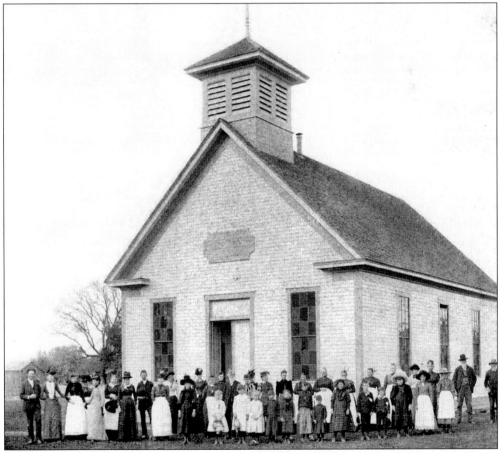

METHODIST CHURCH, C. 1895. The first church in Windsor, Shiloh Church (South Methodist), was established by Parson Cox in 1853 in the present-day Shiloh Cemetery area. In 1863, when it was apparent that the town's fastest growth was occurring along the main north-south road, a new church was built there, under a large oak tree on the east side of the road (East Windsor). For a time, this second Methodist Church was also used as a school. (Windsor Historical Society.)

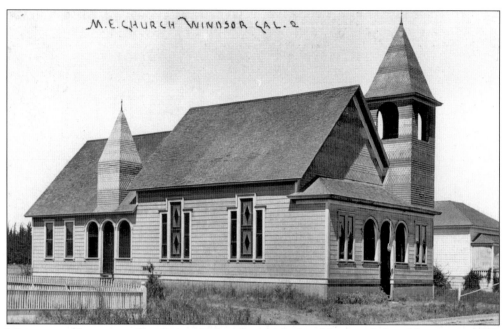

METHODIST-EPISCOPAL CHURCH, 1898. After the railroad bypassed the old town in 1872, practical citizens decided to relocate the church and lodge halls to the west. Shown above, Windsor's second Methodist church, which still stands on Windsor River Road, was constructed for $900. The original parsonage, visible to the right, was moved from East Windsor. (Windsor Historical Society.)

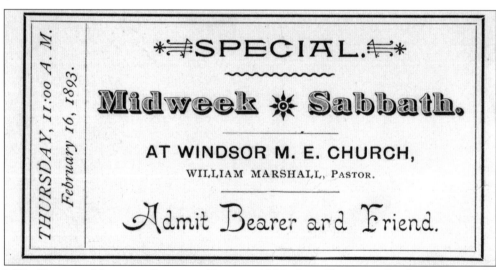

M.E. CHURCH MIDWEEK SABBATH TICKET, 1893. In addition to Sunday services, the faithful attended midweek prayer services, revival meetings, song fests, and other spiritually oriented events.

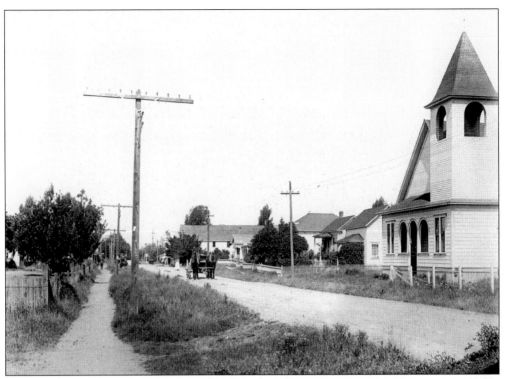

WINDSOR RIVER ROAD, C. 1900. In this west-facing view, the Methodist-Episcopal Church is on the right. (Windsor Historical Society.)

CREATION PROGRAM, 1899. Christian beliefs and moral standards were accepted by most individuals and community groups—from schools to fraternal organizations—which is evident in this advertisement for a religious program presented at Foresters Hall. The Foresters Building was located on the southwest corner of Bell Street and Windsor River Road with the lodge hall on the second floor and Lindsay's Grocery Store below. (Windsor Historical Society.)

CREATION!

World's Most Fascinating Production
FORESTERS' HALL
WINDSOR. CALIF.

FOUR NIGHTS ONLY
Thu., Fri., Sat. and Sun., JUNE 22-25

Complete Change of Program Every Day
Shown in the Best Theaters Everywhere

PART 1
THURSDAY 8:00 P. M.
See the Earliest Dawn of Creation
See This Planet When Land Appears
See the Shadows Flee Away
See Man—the King of All He Surveys
See the First Great Sin
See the First Death
See Human History to the Flood
See the Flood Cover the Earth
See the Tower of Babel
See Abraham Sacrifice His Son

PART 2
FRIDAY 8:00 P. M.
See Moses, Pharaoh and Egypt
See How God "Hardened Pharoah's Heart"
See the First Born of Egypt Die
See the Passover
See the Exodus from Egypt
See David and Solomon
See King Saul Talk to the Dead Samuel
See Mighty Saul's Last Battle
See the Resurrection Pictured

PART 3
SATURDAY 8:00 P. M.
See Nebuchadnezzar's Dream Interpreted
See Daniel in the Lion's Den
See the Birth of Jesus
See the Wise Men Guided by the Star
See Christ from Manger to Cross
See the Miracles of Christ
See Healing Sick and Raising Dead
See Christ Walking on the Water
See the Crucifixion

PART 4
SUNDAY 8:00 P. M.
See the Early Christian Experiences
See the Stoning of St. Stephen
See Them—the Prey of Wild Beasts
See Them Burned at the Stake
See the Massacre of St. Bartholomew
See Napoleon and the Pope
See the Battle of Armageddon
See Paradise Restored
See the Bible Picture of Earth in the Future

FOURTEEN REELS OF THE WORLD'S BEST PRODUCTION
WONDERFUL SYCHRONIZING EXHIBITION
SEE THE HISTORIC CHARACTERS OF ANCIENT DAYS PASS BEFORE YOU IN REALISTIC REVIEW. SPECTACULAR! THRILLING! INTERESTING! DELIGHTFUL! INSPIRING! INSTRUCTIVE! SATISFYING! CAN YOU AFFORD TO MISS IT!

Admission Free Absolutely

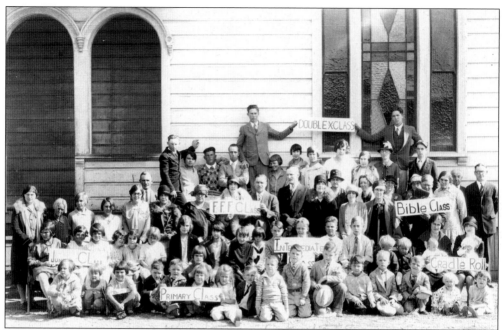

WINDSOR METHODIST CHURCH SUNDAY SCHOOL, OCTOBER 1928. Shown above, John Edward Hinkle is in the center of the picture holding the F.F.F. Class sign; William Beedie, wearing eyeglasses, is on the far right near the Bible Class sign; and in the front row George Hinkle is third from the right and Ed Hinkle, holding his hat, is sixth from the right.(Hinkle family collection.)

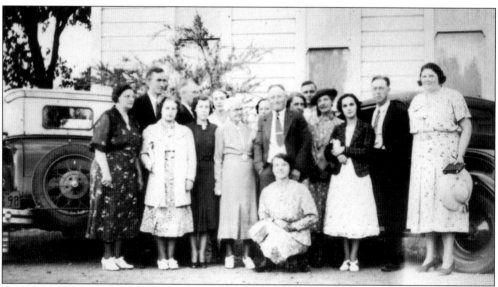

METHODIST CHURCH MEMBERS, LATE 1930S. Friends are, from left to right, (front row) Edith Hinkle, Edna Robbins, Isabel Beedie, Ella Welch, Jack Beedie with his wife, Lillian Silk Beedie (crouching), Irene DuVander, Don DuVander, and Eloise Robbins; (back row) Chet Robbins, unidentified, Lura Welch, Lois Welch, unidentified, unidentified, and Pearl Robbins (in black hat). (DuVander family collection.)

56

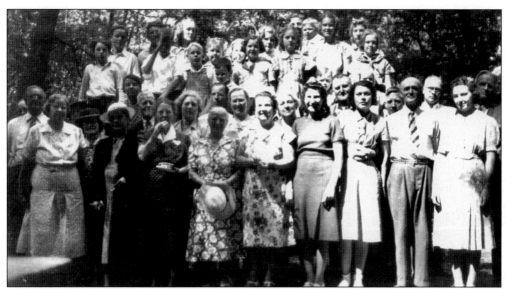

METHODIST CHURCH PICNIC, LATE 1930s. During simpler times, warm weather holidays were celebrated with picnics. Two popular picnic areas were Wilson's Grove, where the above photograph was taken, and Pohley's Grove. (Windsor Historical Society.)

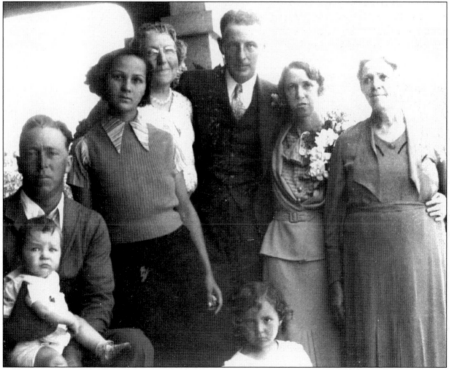

WEDDING DAY AT THE DUVANDER HOME, 1936. Pictured above are, from left to right, Don DuVander holding daughter Georgie, Irene DuVander, Rev. Margarite Cole of the Windsor Methodist Church, newlyweds Bill and Dorothy DuVander Johnson, Laura Elsbree DuVander, and toddler Donna DuVander standing in front. During the Great Depression when money was scarce, most weddings were simple affairs. (DuVander family collection.)

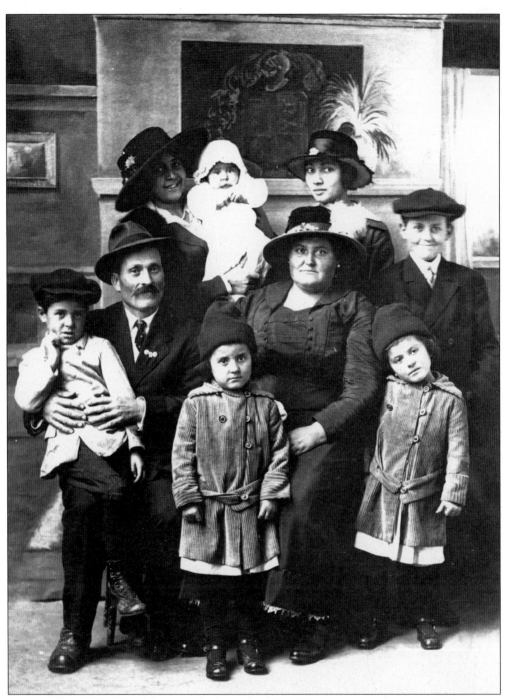

BAPTISM DAY, 1919. There was no Catholic church in Windsor during the early 1900s so baby Josephine Diamantini was baptized at St. John's Catholic Church in Healdsburg. Other family members include, from left to right, Victor on father Remigio's lap, mother Elvira, twins Delia and Sterina, and Angelo. (Blasi family collection.)

Five

A DAY ON
THE RANCH

Most of Windsor's pioneers were farmers who emigrated largely from Southern states but also from Europe, bringing with them agricultural skills and a no-nonsense work ethic, typically laboring from sunup until sundown. In the 1800s, the farmers' survival depended on crops they grew, such as hay, potatoes, and corn. They planted vegetable gardens, grapevines, and orchards, and raised livestock and poultry. Later, large-scale hop fields, vineyards, prune orchards, and chicken ranches provided new opportunities. Life was a constant struggle, and there may have been more bad years than good, but when farmers looked back over the seasons they had worked the land, most recalled more joys than disappointments.

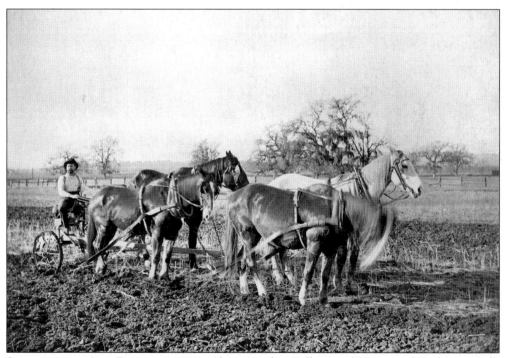

STATE-OF-THE-ART PLOW, C. 1890. Above, Luther Bell, son of Henry and Catherine Bell, proudly displays Windsor's first gang plow, which had several blades that cut parallel furrows. (Windsor Historical Society.)

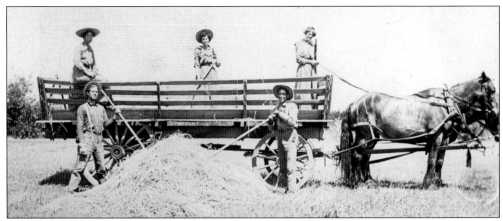

ARATA HAY HARVEST, EARLY 1900S. In 1898, hay fields covered 39,850 acres in Sonoma County, many of them in Windsor. The Arata Ranch harvesters pictured above are, from left to right, (front row) Ed Crandall and Jack Arata; (back row) Kate Arata, Rose Arata, and Margaret Davies. (Arata family collection.)

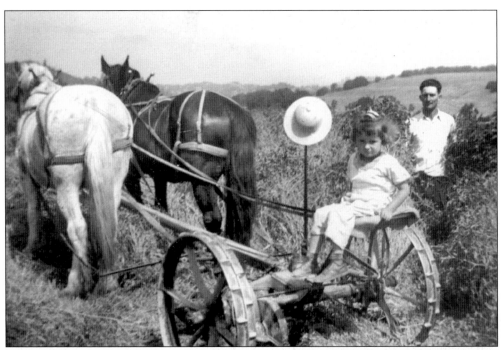

MOWING HAY, 1940. On a warm June day, Beverly Greeott, age three, accompanied her daddy at work. It was a memorable season, the last year George Greeott used horses to mow his abundant crop of oats, vetch, and rye grass. The white Percheron in the snapshot is Queen, one of George's favorites. (Greeott family collection.)

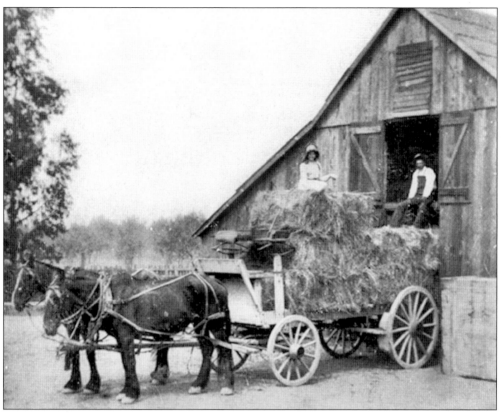

DRAFT HORSES EARN THEIR KEEP. In this early 1900s photo, Louis Arata and an unidentified woman prepare to unload a hay wagon on the Arata Ranch. A family orchard can be seen in the background. (Arata family collection.)

HAY OVERLOAD! 1930S. During the event pictured above, the Brooks family may have been longing for their old horse and wagon. Arthur Brooks and Leta Brooks DuVal stand; Albert Brooks perches on the truck's fender. (Brooks family collection.)

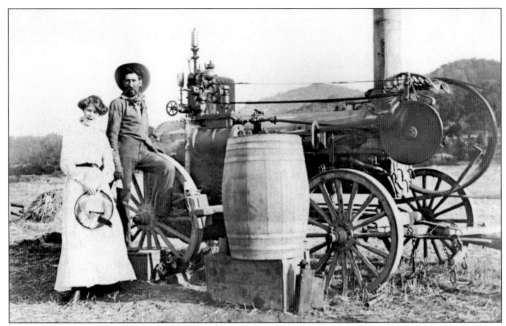

HEAVY EQUIPMENT, EARLY 1900S. Benito Arata planted a wide variety of crops on his 155-acre ranch, including many acres of hay. In this photograph Margaret Davies and Louis Arata pose beside a steam-powered threshing machine. Louis, while working as a hop-kiln fireman, acquired knowledge of steam engines, which he later used on the ranch. (Arata family collection.)

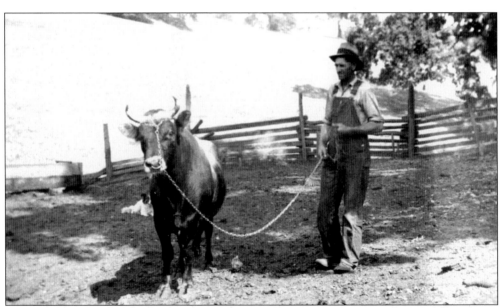

WALTER KIMES WITH HIS PRIZED JERSEY BULL, 1929. Walter Kimes operated award-winning dairies on the Harry Calhoun Ranch and the Louis Locatelli Ranch. In 1932, Kimes helped organize the Sonoma County Milk Producers Association, serving on its board of directors and as vice president from 1941 until his death in 1949. (Kimes family collection.)

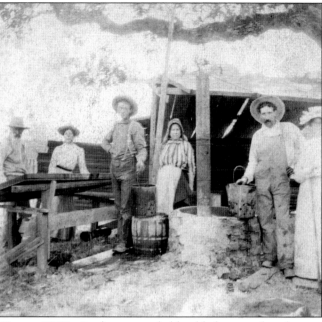

Picking and Dipping Prunes, Early 1900s. In these remarkable old photographs taken on the Arata Ranch, family members (left), including a woman in a long dress and bonnet, pick prunes. Then in the next processing step (right), the prunes are being dipped in a lye mixture after which they will be spread on trays to dry. Louis Arata is on the right; Theresa Arata, center. (Arata family collection.)

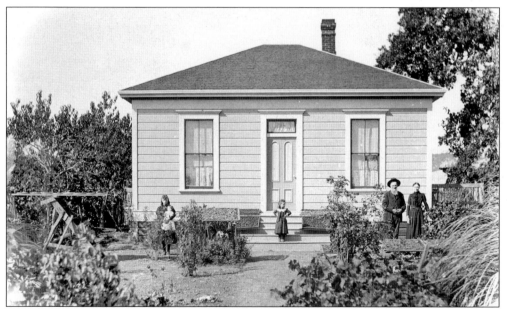

Drying Prunes, c. 1900. Photographed in the fall, this unidentified Windsor family's yard is filled with prunes drying in trays. The dried fruit would have been enjoyed throughout the winter. (Windsor Historical Society.)

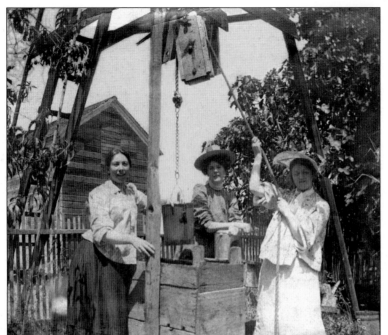

DRAWING WATER FROM THE WELL, EARLY 1900S. Obtaining even the most basic necessity of life, water, required considerable effort in bygone days. Here, Kate Arata, left, and friends look forward to a sip of cool water from the Arata Ranch well. (Arata family collection.)

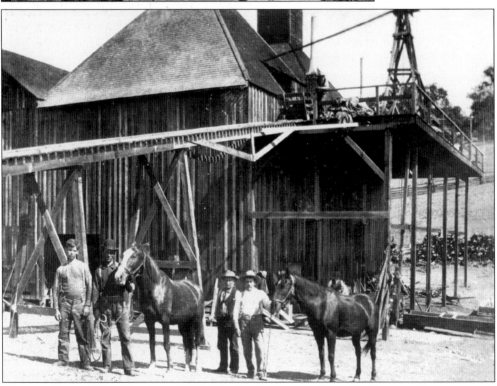

WOHLER RANCH HOP KILNS, C. 1900. The first hops were planted in Sonoma County around 1880 and by 1915 covered approximately 2,300 acres. At least 10 hop ranches stretched along Mark West Creek from the Finley Ranch near Larkfield to the Wohler Ranch at the juncture of Mark West Creek and the Russian River. (Arata family collection.)

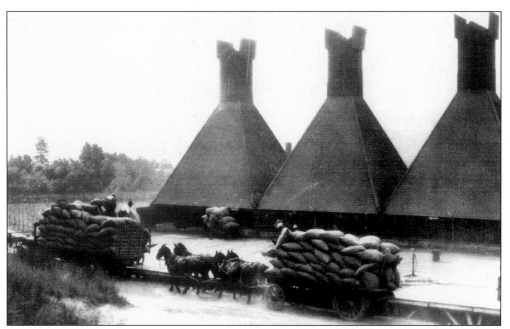

GREEN HOPS HEADED FOR THE KILNS, C. 1900. Kilns were fueled by manpower, "firemen," who generally worked 12-hour shifts. (Windsor Historical Society.)

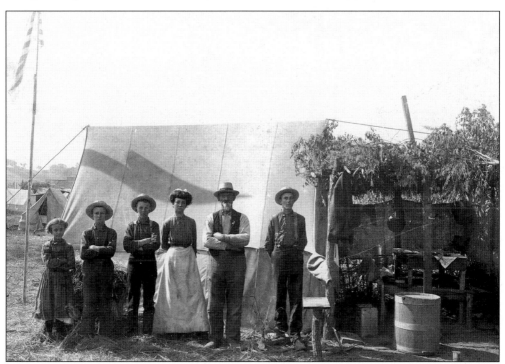

HOP FIELD CAMP, C. 1903. In this photograph, John Weston Williams and five of his fourteen children pose next to their tent. John Williams was a patriotic Civil War and American Navy veteran who flew the American flag wherever he lived, even in the hop field. (Greeott family collection.)

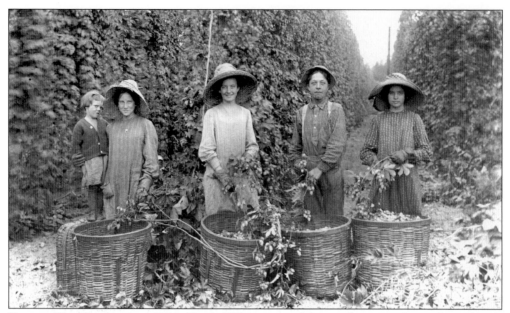

FILLING HOP BASKETS, C. 1900. Hardy Wilson, second from right, was a descendant of 1854 pioneer Alex Wilson, whose large ranch was located in the Eastside Road area. The girls above are believed to be members of the Grant family. Hop pickers' hands were covered with gloves and tape to protect them from the prickly vines. Hops were picked into baskets, then dumped into sacks. (Windsor Historical Society.)

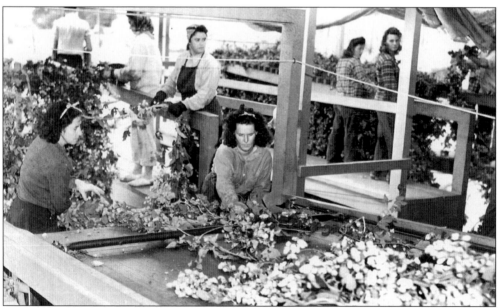

STRIPPING HOP VINES, C. 1935. During the late 1930s, hop-picking machines were invented that allowed ranchers to streamline their work. However, modern machinery was no match for the onslaught of downy mildew that settled upon Sonoma County hop yards in 1934 and eventually devastated the industry. (Windsor Historical Society.)

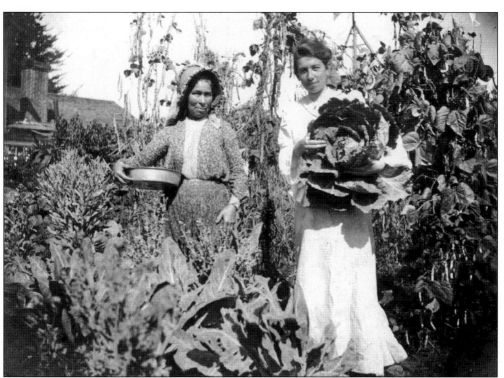

A Wonderful Windsor Garden, c. 1910. Theresa Arata and Jetta Raffo are gathering vegetables in the abundant garden on the Arata Ranch. Jetta is holding a gigantic cabbage. Every year, housewives "put up" large quantities of fruit and vegetables, preserving them in jars for winter use. (Arata family collection.)

Sampling Grapes, c. 1910. During the spring of 1885, immediately after purchasing his ranch, Benito Arata planted 15 acres of fruit trees and 18 acres of grapes, mostly Zinfandel but other favorite varietals, too. Grapes were used for homemade wines and also sold to wineries. Tasters in this picture are, from left to right, Frank Alviso, Jetta Raffo, Jack Arata, and Louis Arata. (Arata family collection.)

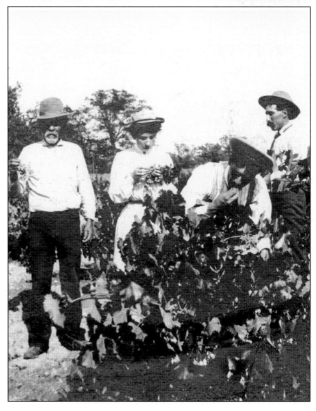

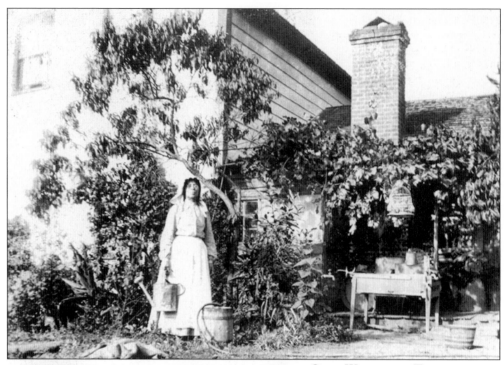

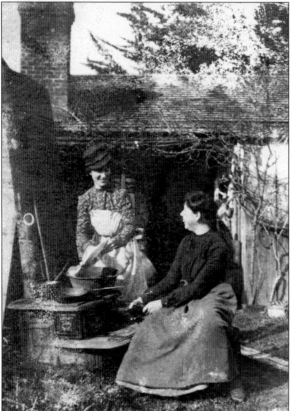

COOL WATER FOR THIRSTY PLANTS, C. 1900. During hot weather Theresa Alviso Arata spent a good deal of time watering plants in the yard behind the two-story Arata home. The hose would also have been handy in the event a fire broke out, which was always a significant risk in old Windsor. (Arata family collection.)

A WOMAN'S WORK, EARLY 1900s. In this snapshot, Kate Arata, right, and a friend wash dishes in the outdoor kitchen adjacent to the Arata family home. Outdoor kitchens, complete with a wood stove for cooking and heating water, were especially popular during hot summer months. Hearty ranch meals were prepared three times a day—breakfast, dinner (lunch), and supper. (Arata family collection.)

THE BUTCHER, C. 1930. In bygone eras, all animals were butchered locally. In this photograph, C.J. "Toots" Martin, on the right, displays a freshly slaughtered hog carcass in front of the Martin Meat Market. There was a slaughterhouse on Windsor Road, which Martin operated, but most people butchered their own livestock and poultry at home. Butchering day typically began at dawn and involved the entire family, even young children. It was an unpleasant but necessary task, routinely completed by folk who believed the sole purpose of farm animals was to provide food and other products for the family. (Windsor Historical Society.)

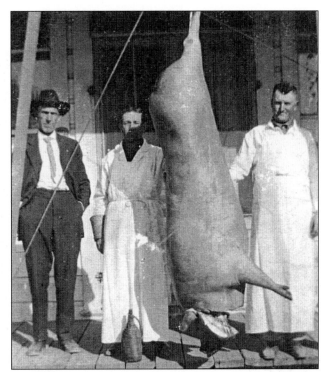

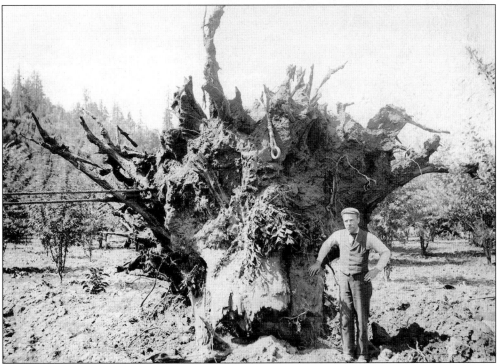

CLEARING LAND, C. 1890. Shown here, Luther Bell stands beside massive tree roots, probably being removed to make way for agriculture. Clearing land required much time and physical effort on the part of man and beast. (Windsor Historical Society.)

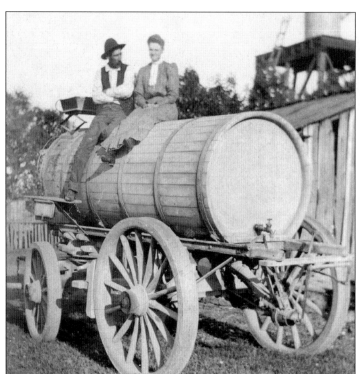

ON THE WAGON, EARLY 1900S. Unpaved roads, which included most of the byways in the county, were deeply dusty during dry weather. The Aratas enjoyed the luxury of a horse-drawn water wagon, which was used to settle dust on their ranch. In this snapshot, Louis and Sophia Arata sit atop the wood water container. The vehicle's driver's seat is visible behind Louis. (Arata family collection.)

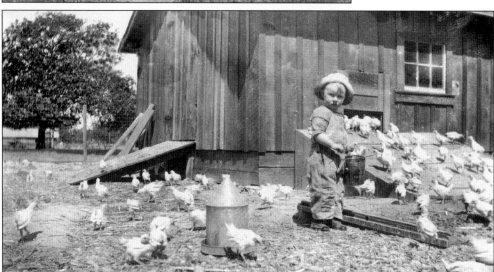

FEEDING WHITE LEGHORNS ON THE ARATA RANCH, C. 1910. When this picture was taken, neither little Norman Ward nor anyone else imagined that by the 1920s chickens would be big business in Windsor. At one time, 16 to 20 thriving poultry ranches were located on Starr and Gumview Roads with farmers' flocks averaging 3,000 to 5,000 hens. During that era, large companies put eggs in cold storage in the spring and took them out in the fall when prices were higher. Frank J. Pool regularly received eggs, then hired men to candle them (examine them one by one in front of a light for impurities), and repack them for shipment to San Francisco. Howard Pohley and others worked Pool's candling room, often processing 45,000 eggs per day. (Arata family collection.)

THE GRANGE HALL, ERECTED IN 1941. Through the years, Windsor citizens have volunteered their skills, talents, and countless hours to build community facilities and provide beneficial programs. The building shown above was erected under the supervision of cabinet maker Rollo Jones with assistance from many others. Windsor Grange's first meeting in the new building, June 22, 1942, was attended by the following grange leaders: Rollo "Rolly" Jones, grand master; Fred Harding, overseer; Edith Silk, chaplain; Josephine Harding, lecturer; Mamie Silva, Ceres; Sophia Arata, Pomona; Julia Urman, Flora; Sgt. George C. Laumann, acting master; Esther Goode, acting overseer; Louis Arata, Joe Goode, Bert Small, and Henry Burdin, altar bearers; Cora Shriver, Bible bearer; Barbara Cook, flag bearer; Helaine Taylor, pianist; and Beth Harding, soloist. (Rebich family collection.)

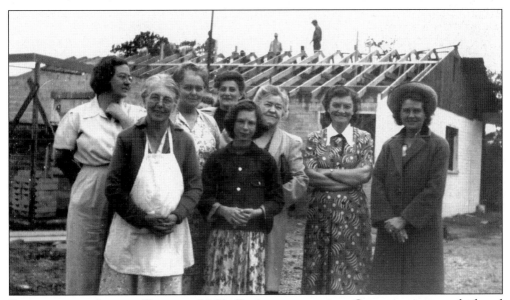

BUILDING THE JUNIOR GRANGE, 1949. During construction, Grange women cooked and served meals to workers. Women identified in this picture are, from left to right, (back row) Faye Walden and Hazel Williams; (front row) Amy Jones, wearing an apron. (Rebich family collection.)

71

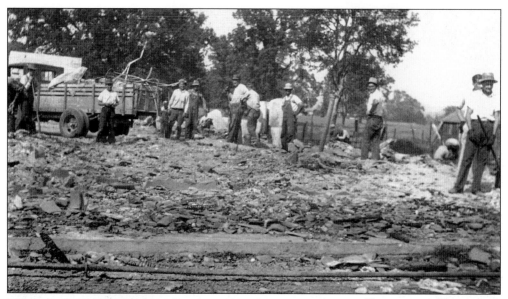

DOWNTOWN DISASTER CLEANUP, C. 1940. Local citizens shouldered the responsibility for cleaning up the town and helping neighbors after disasters, which included numerous single-dwelling and grass fires every decade and major fires in 1905, 1920, 1932, 1940, and the great earthquake in 1906. (Windsor Historical Society.)

BROOKS RANCH WORK BREAK, 1930s. When a neighbor dropped by during a long, hot day of wood-chopping, the Brooks men found it a welcome relief to stop working and visit awhile. Pictured here are, from left to right, (front row) Charles Brooks and Albert Brooks; (back row) Jim Esserling, Alice Brooks, and Arthur Brooks. (Brooks family collection.)

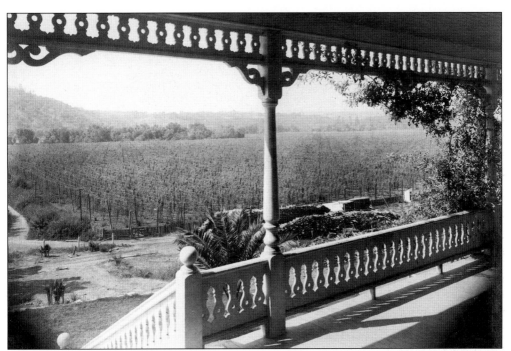

VIEW FROM THE WOHLER RANCH HOUSE, EARLY 1900S. Shown above are some of the hops planted on 250 acres of the Wohler Ranch. More than 1,000 pickers were needed during the harvest season, which in peak years yielded 3,000 bales, or approximately 600,000 pounds of hops. (Healdsburg Museum.)

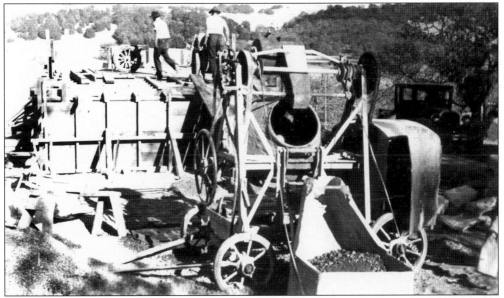

MIXING AND POURING CEMENT, 1939. In building the Greeott Ranch 28,000-gallon water tank, George Greeott and friends used a gasoline-powered cement mixer. LaFayette Beeman and his brother Frank manned "cement buggies" on top of the tank, dumping cement into the forms, round and round, which was then continuously tamped by individual manpower. (Greeott family collection.)

73

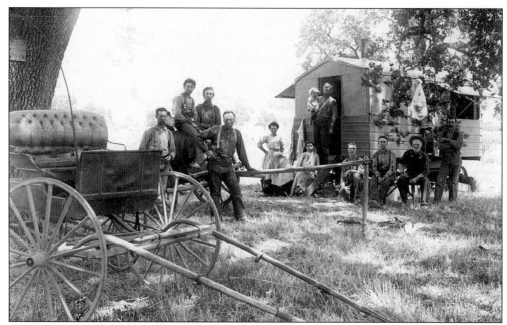

COOKHOUSE, C. 1899. When hay fields covered thousands of acres in the Russian River Township, a portable cookhouse was used during harvest seasons to provide meals for workers. James Hudson stands on the left nearest the buggy, and his wife, Mamie Hudson, the cook, is the woman with her hand on her hip beside the cookhouse. (Healdsburg Museum.)

A MILE OF PRUNE TREES, C. 1949. From left to right, sisters Marilyn and Donna DuVander are shown sitting on the lawn in front of the family home. In the background, looking north across the garden, is a prune orchard that extended for a mile (an area that is now part of Windsor's Lakewood Shopping Center). At the time of this snapshot, the trees were heavily laden with fruit, so props (wood poles) supported the limbs to keep them from breaking. (DuVander family collection.)

Six

SCHOOL DAYS

In the late 1800s, there were several one-room schools in Windsor, located within walking distance of homes, which might be several miles away. One teacher taught first to eighth grades and was usually responsible for stoking the wood-burning stove, drawing water from the well, and cleaning the building. Typically, the room was divided according to grade level and gender, and emphasis was on reading, writing, and arithmetic. Misbehavior was quickly corrected with reprimands—pulling hair or an ear, pinching, swatting, rapping knuckles with a ruler, or administering a "licking" with a sturdy stick. Long after Windsor's modern multiroom grammar school was built in 1909, the old teaching and discipline methods continued.

FIRST DAY OF SCHOOL, 1914. In this classic photograph, twins Don and Dorothy DuVander, age six, lunch basket in hand, are ready to walk the 1.2 miles from their home to Windsor School. From left to right in the background are the children's father, George DuVander, friend Jean Wilson, and mother, Laura DuVander. (DuVander family collection.)

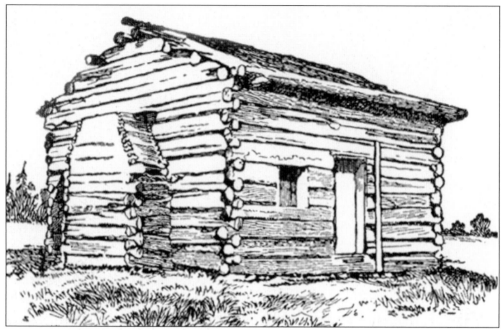

WINDSOR'S FIRST SCHOOL, 1853. There is no known photograph of Prewett School (some called it Shiloh School) but local histories state it was a small log structure, which probably resembled this illustration from an 1870 school reader. The school was located near Shiloh Cemetery and John Prewett was the first teacher. (Author's collection.)

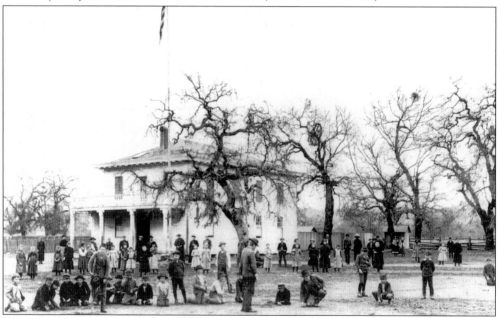

WINDSOR SCHOOL, C. 1863. With the town rapidly growing on the east side, it seemed prudent to build a new and larger school there, so Prewett School was replaced by a $2,000 structure east of the main road. Originally the school was a one-story building, but when the Masonic Lodge was organized, the group added a second story to be used as their lodge hall. (Windsor Historical Society.)

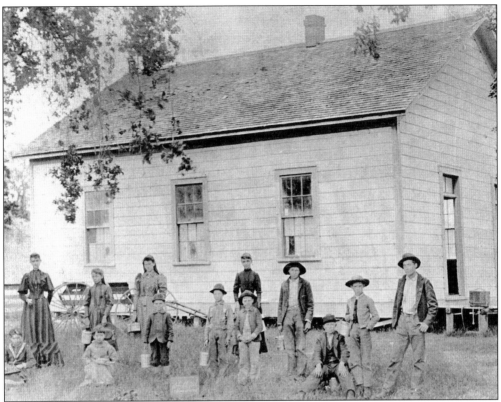

HILL SCHOOL, MAY 21, 1892. Hill School, built in 1863, was located on Chalk Hill Road. The one-acre school site, part of the Glen Valley Springs Ranch, was donated by Sarah Myer Rich in memory of her husband, Jacob, who died in 1862. Robert Hill, for whom the school was named, was its first teacher. Hill School burned in the late 1800s, was rebuilt, and remained active until 1937 when attendance declined and Hill School District was annexed to Windsor School, creating Union School District.

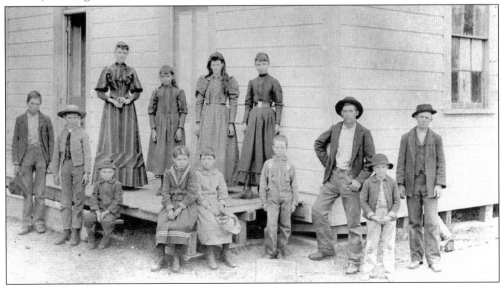

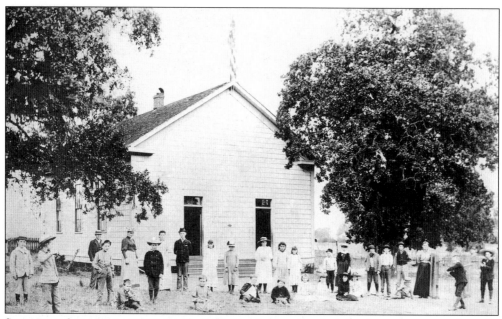

SOTOYOME SCHOOL, C. 1892. Baseball has long been a popular school activity, even when the bat was no more than a hefty stick. In this photograph Homer Hotchkiss (second from right) prepares to hit a pitch lobbed in by Joe Miller (second from left) with ? Miller catching. Other individuals on the playground, whose names were recorded on the back of the old photograph, include Harry Brown, teacher Emma Wightman, Marius Hotchkiss, ? Ward, Adda Brown, ? Savaroni, Flora Wright, Hazel Hotchkiss, Dixie Nalley, Ned Nalley, and ? Bacigalupi. In the photo above, note the school's two entry doors—one for boys, one for girls—which opened into the cloak room. (Hotchkiss family collection.)

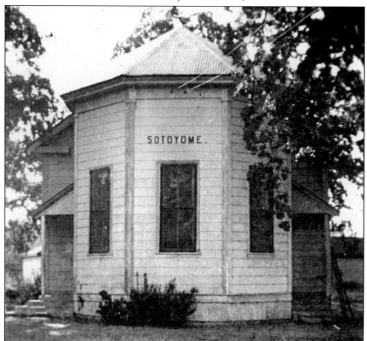

END OF AN ERA, 1950S. Sotoyome School was built in 1872. Like most one-room country schools in Sonoma County, Sotoyome School District's student enrollment declined after World War II, and it was annexed to Windsor Union School District in 1956. (Windsor Historical Society.)

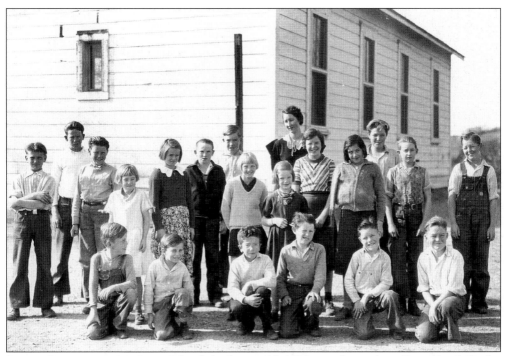

STARR SCHOOL, 1936. Starr School, built around 1880, was located on Starr Road. In the picture above, Gene Walker is one of the students and Miss McKee is the teacher. In 1951 the school closed and Starr School District was annexed to Windsor Union School District. (Windsor Historical Society.)

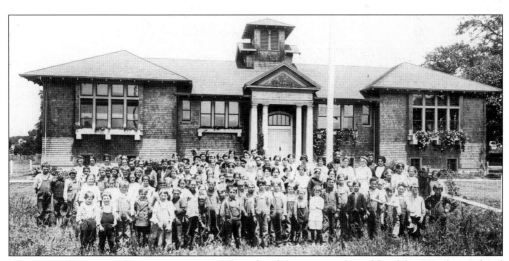

WINDSOR GRAMMAR SCHOOL, C. 1909. The school district purchased land for Windsor School on September 18, 1897, but did not erect the structure until 1908. The school was constructed with three rooms, and a fourth room was added later. At the time, it was recognized as one of the most beautiful and modern rural schools in California. (Windsor Historical Society.)

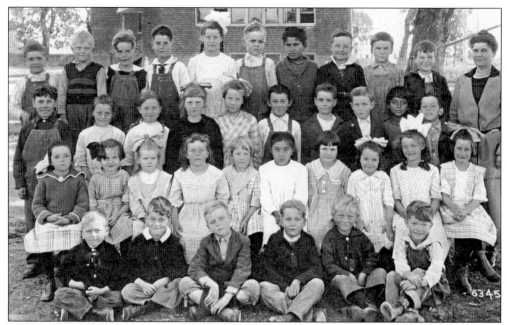

WINDSOR SCHOOL, C. 1922. Fritz Gabelin is the boy seated to the far left in the front row. The teacher is Miss Mattie Washburn. (Windsor Historical Society.)

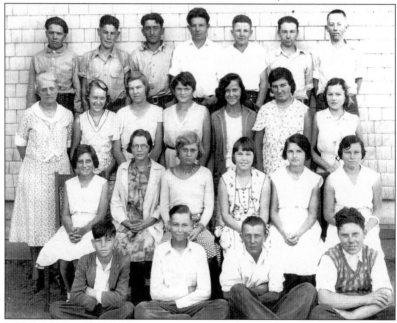

WINDSOR SCHOOL, C. 1931. The students pictured here are, from left to right, (front row) unidentified, Douglas Jensen, Frank Hardina, and Norman Combs; (second row) Marie Conde, Catherine Ginzer, unidentified, Mabel Pearson, Ora Walden, and Rena Rossetto; (third row) principal and teacher Bertha Johns, Helen Winset, Audrey Lindsay, Guila Small, Irene Horvath, Sterina Diamantini, and Laura ?; (back row) Will Rockstroh, Alex DiCicco, Alio Blasi, Everett "Butch" Adams, Carl Hilbur, Homer VanWinkle, and Jack Eagan. (Windsor Historical Society.)

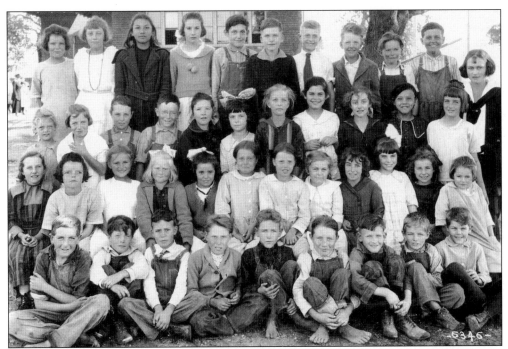

FOURTH GRADE CLASS, WINDSOR SCHOOL, 1921–1922. The students are, from left to right, (first row) Jim Hembree, Alvin Baldwin, Clifford Rich, Lloyd Smithers, unidentified, Edward Hinkleman, Jim Hagadorn, Albion Greene, and Esthel Lindsey; (second row) Margie Carter, Eva Purcell, Lila Small, Helen Beggars, Angelina Shiotta, Mary Urman, Frances Urman, Freida Gebelin, Marion Toso, Helen Russell, Chrysty Carter, and Margarite Purcell; (third row) Bertha Seslar, Iris Pitkin, Robert Hastings, Emmet Rochester, Edith Lolo, Doris Thomas, Olive Knorr, Evelyn Rhodes, Emma Waltenspiel, Katharine Larson, Lorena Hembree, and Miss Packwood; (fourth row) Iva Purcell, Alma Purcell, Pauline Larson, Berdina Bell, Leslie Burkhead, Richard Hagadorn, Franklin Lewett, Joseph Dowd, Harold Baker, and Angelo Diamantini. (Healdsburg Museum.)

LEARNING TO READ, 1870. Typical public school readers and classroom instruction included the fundamentals of elementary education (the three R's—reading, 'riting, and 'rithmetic) as well as lessons in personal discipline, deportment, morality, and religion. (Author's collection.)

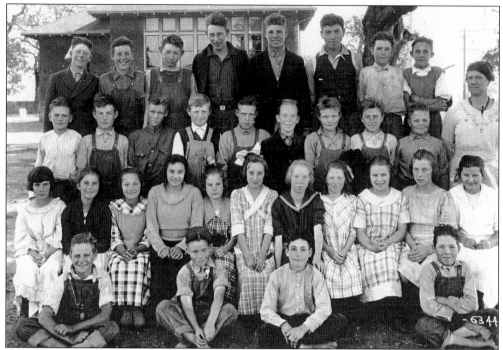

WINDSOR SCHOOL CLASS, C. 1920. Students are, from left to right, (first row) ? Hinkleman, Alva Rochester, Frank Frediani, and Billy Carter; (second row) Emma Smithers, Joan Harris, Olga Biocca, Alice Toso, Margaret Russell, Mary Dawes, Dorothy DuVander, Marie Pohley, Ivy Rich, Etta Hastings, and Lillian Bell; (third row) Ted Linders, Frank Nowlin, Wendell Packwood, John Leubberke, Harold Parkerson, Don DuVander (Dorothy DuVander's twin), Edward Hinkleman, Frank Werner, and George Rich (Ivy Rich's twin); (fourth row) Ralph Pohley, Jack Carter, Estel Purcell, Hugh Young, Irving Rinaldo, Albert Larson, Henry Dowd, and Alton McCracken. The teacher is Mrs. Olive Taylor. (Windsor Historical Society.)

THE TREE THAT WAS ONCE LITTLE.

LESSON FROM A REDWOOD TREE, 1870. Children nationwide were learning about California through school readers by the late 1800s. In this story, a father takes his offspring to see California's giant redwood trees, teaching them that by persevering through life's challenges, they, too, can grow to be mighty in their achievements. (Author's collection.)

Seven

FAMILY

THE TIE THAT BINDS

In Windsor's pioneering days, the dance of life revolved around the family. Families tended to be large and family members depended on one another to perform household and ranch chores, nurture and teach younger children, care for the elderly, and provide material and emotional support throughout life. In most families, siblings were one's closest playmates and lifelong best friends; one of society's greatest tragedies was to bring shame and dishonor on parents or the family. In time, technological advances brought many major changes including fewer children; nevertheless, in Windsor, family life remained the community's focus.

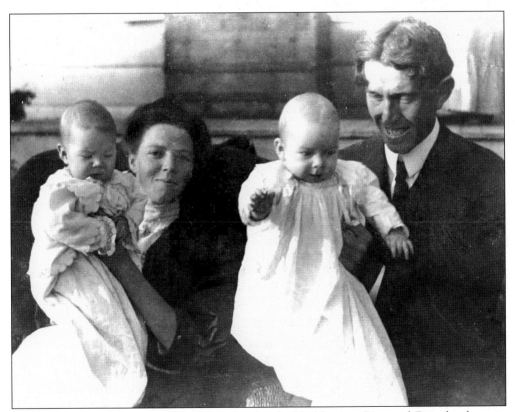

TWINS! Laura and George DuVander enjoyed a double blessing, Don and Dorothy, born in 1908. (DuVander family collection.)

WARM WEATHER WASH, 1908. Whether it was a proper soap-and-water bath or simply a cool splash on a hot day, Stanley Arata appears content in this snapshot. Meanwhile, his mother, Sophia, holds her pride and joy securely. (Arata family collection.)

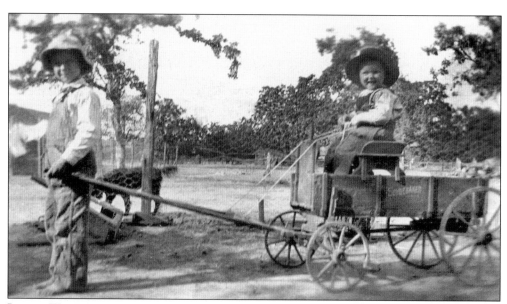

LITTLE WAGONMASTER, C. 1912. Being older, it was appropriate for Stanley Arata to serve as the horse pulling Clayton Ward in a Studebaker wagon. The boys enjoyed many excellent adventures together on the vast Arata Ranch. (Arata family collection.)

Hazel Hotchkiss and Her Four Brothers, c. 1890. Hazel Hotchkiss, born December 20, 1886, spent her early childhood on the family's Eastside Road ranch, settled by her grandfather Benoni Hotchkiss. There, she developed athletic skills competing with her brothers in many activities, including baseball and pole vaulting over barbed wire fences. As an adult, Hazel became a world-famous tennis champion. In this photograph, the siblings are, from left to right, (front row) Hazel, Homer, and Linville; (back row) Miller and Marius. Yes, Linville is a boy! During the 1800s, young boys were often clothed in dresses and their tresses coiffed in long curls. (Hotchkiss family collection.)

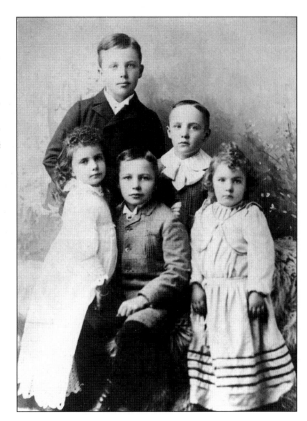

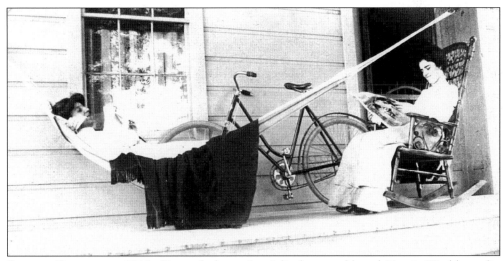

Sitting Pretty, c. 1912. Pictured above, Ina ? (in hammock) and Vernie Washburn (in rocker) relax on the porch of the Washburn home on Franklin Street. Vernie enjoyed taking photographs and developing and printing film. (Windsor Historical Society.)

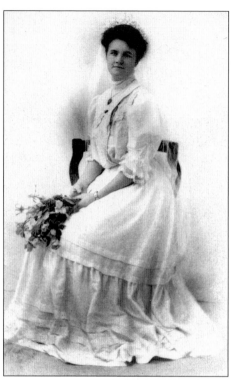

A Beautiful Bride, 1906. Sophia Maxwell Davies Arata, wife of Louis Arata, posed on her wedding day for this traditional photograph. Her bouquet of roses is a classic symbol of love, beauty and hope. (Arata family collection.)

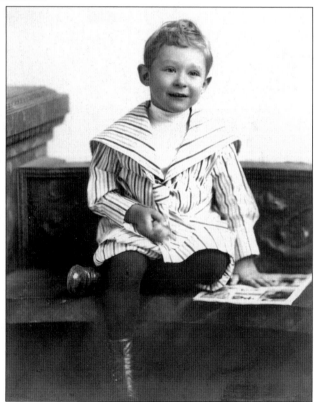

Little Charmer, Stanley Davies Arata, 1911. In this appealing childhood portrait, little Stanley, age three, son of Louis and Sophia Arata, is dressed in a stylish sailor suit and high button shoes. (Arata family collection.)

A Future Champion, 1920. When this snapshot was taken, no one had any idea that George Greeott, then age 12, would grow up to be, in addition to other life successes, a champion horseshoe pitcher, inventor of a widely acclaimed horseshoe (the Greeott Grabber), and greatly admired folk artist. Currently a member of the Northern California Horseshoe Pitching Association Hall of Fame, he is still pitching horseshoes in his nineties. One of his greatest artistic achievements is a unique collection of 90 carved wood tools that are precise replicas of antique metal implements. (Greeott family collection.)

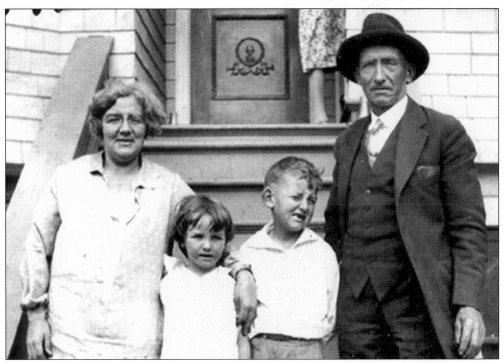

Visiting Nain and Taid, 1928. The Richards children, Gladys, age six, and Berwyn, age eight, enjoyed visits with their grandparents in San Francisco. Welsh immigrants whose native tongue flavored their English, Margaret and Frank Davies were lovingly called Nain (grandmother) and Taid (grandfather). (Engelke family collection.)

A Picture of Prosperity, c. 1920. Shortly before moving from Montana to California, Louis and Kate Horvath took this picture of their children; they are, from left to right, Frank, Irene, Margaret, and Elizabeth. The photograph of the healthy, well-fed youngsters dressed in fine clothes was ideal for the family album and might also have reassured relatives in Hungary, the Horvath's homeland, that they were prospering in America. (DuVander family collection.)

Father and Son, c. 1949. It was early on a foggy Windsor morning when this picture was taken. Stan Arata and his son Don were headed out to work on the Arata Ranch. Behind them is the "help house" for hired hands. (Arata family collection.)

MEMORIES OF A 1933 CHIVAREE. A few weeks after Irene Horvath and Don DuVander's wedding, they were surprised with a chivaree. Late one night the Burkhead boys, Johnny Moose, and others frightened the newlyweds by shaking their house with a saw blade attached to the building and set in motion with a bull gear. Then, after eating all the food in the kitchen, the rowdy revelers kidnapped Irene and Don, placed them in a buggy that was secured to the rear bumper of a car, and paraded them down Pleasant Avenue, through the town of Windsor, and back to the beginning of Pleasant Avenue. At this point the buggy was unhooked and Don, being harassed all the way, was forced to pull the buggy, with his bride in it, back home. Pulling into their driveway, Don and Irene were horrified to discover everything from their bedroom scattered all over the yard. And then it began to rain . . . (DuVander family collection.)

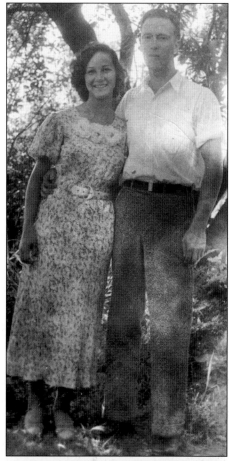

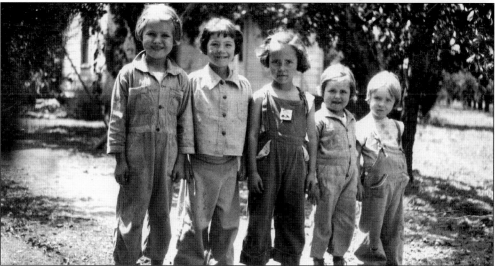

LITTLE FARM GIRLS, C. 1939. The playmates pictured above are, from left to right, Barbara Robbins, Joyce Cameron, Donna DuVander, Betty Robbins, and Georgiana DuVander. (DuVander family collection.)

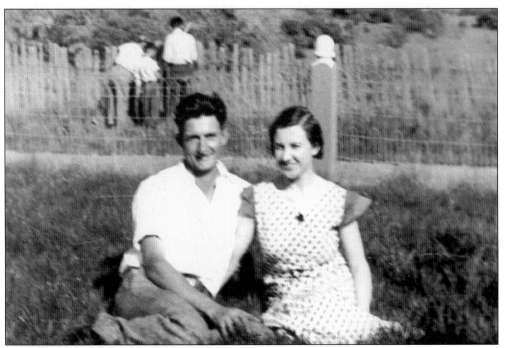

NEWLYWEDS, 1936. On a warm spring day George and Isabel Greeott smiled for the camera as they relaxed on the lawn of John and Sarah Greeott's home, one of three family dwellings on the Chalk Hill Ranch. Directly behind the happy couple, Chalk Hill Road is visible. (Greeott family collection.)

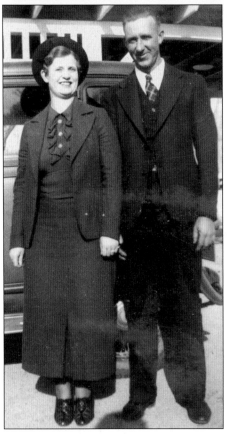

DECEMBER BRIDE AND GROOM, 1936. Alice and Albert Brooks were married on December 5, 1936, in Carson City, Nevada, then settled into a home at the end of Cunningham Lane (now Brooks Road), on the family's original homestead property. In 1938 they bought their own land—54 acres that adjoined the southern edge of the Brooks homestead—from Edwin Richards. In 1955, Albert Brooks passed away unexpectedly, leaving Alice with 6 children who ranged in age from 6 to 17: Vernon Albert, Wesley Allen, Carole Louise, Marilyn Blanche, Virginia Alice, and Janet Ruth. Facing adversity bravely, Alice managed to stay home with her children, meeting financial needs through ranching, wood sales and, within a year, the Brooks Rock Quarry. (Brooks family collection.)

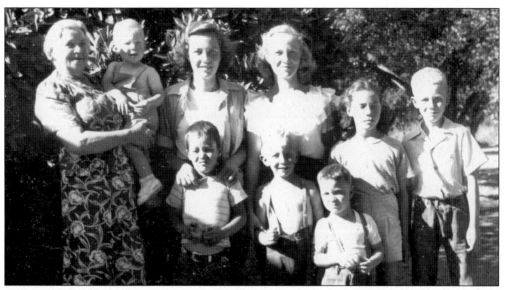

GRATEFUL GRANDMOTHER, C. 1949. For this photograph Laura Elsbree DuVander smiled with delight as she gathered her grandchildren around her—toddler Gary Johnson in her arms—and, from left to right, (front row) Jim DuVander, David Johnson, and Ted DuVander; (back row) Donna DuVander, Georgiana DuVander, Marilyn DuVander, and Richard Johnson. (DuVander family collection.)

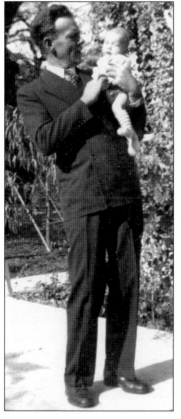

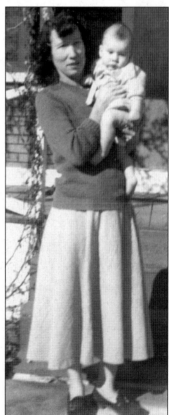

ELSBREE EXCITEMENT, 1949. These snapshots reveal the joy Charles "Pat" and Elizabeth "Lisa" Elsbree felt for their children: Charles "Sonny," Don, Jack, Patty, and Candy. The Elsbree Ranch included acreage on which now stand Windsor Junior High School, Pat Elsbree Skate Park, Hiram Lewis Park, and the Elsbree Estates homes. (Elsbree family collection.)

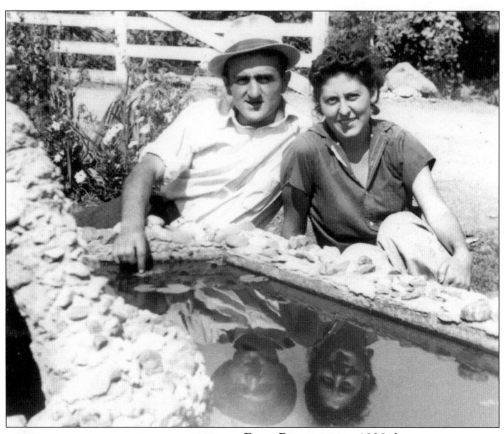

FOND REFLECTIONS, 1938. It was a picture-perfect day as Mario and Josephine "Jo" Blasi paused for a snapshot beside a rock fish pond built by Jo's father, Remigio Diamantini. (Blasi family collection.)

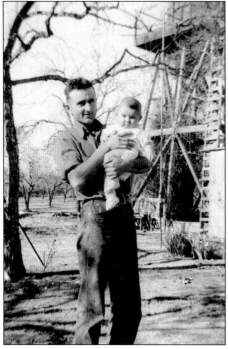

FUTURE FARMER, 1942. Soon after Mario and Josephine Blasi's first son, Gary, was born, his daddy began taking him on tours of their Pleasant Avenue ranch, introducing him to the rich land Mario loved, and teaching him farming skills he would use all his life. Gary happily followed in his father's footsteps, first through the prune orchards visible in the background of this snapshot, and later through vast vineyards. (Blasi family collection.)

Eight
PAST PLEASURES

During Windsor's first century people enjoyed simple, generally close-to-home pleasures. They delighted in holiday parades featuring festive floats and the town band, rodeos, picnics, athletic competitions, and pie- and watermelon-eating contests. Women gathered for afternoon tea parties and sewing, and fraternal organizations hosted dances. Together they swam in the river or a lake, went camping, hunted, fished and, for a fortunate few, there were family vacations in San Francisco, Yosemite, Hawaii, and other distant locales.

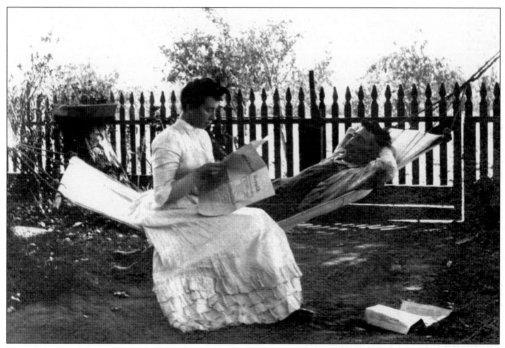

THE LATEST NEWS, EARLY 1900S. At the end of an exhausting work day on the ranch, Louis Arata liked to relax in a hammock while his wife, Sophia, read the latest news to him from the *Windsor Herald*. This photograph was probably taken at the beginning of the harvest season for a "school outfitter" had placed a sizeable advertisement on the front page of the newspaper. (Arata family collection.)

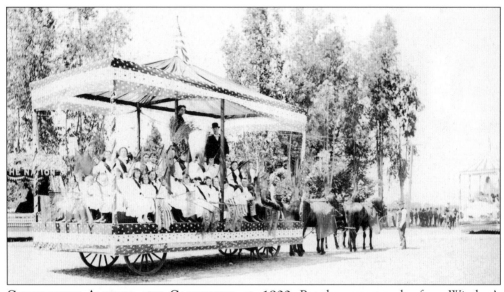

CELEBRATING AMERICA AND CALIFORNIA, C. 1900. Parades were popular from Windsor's earliest years, and this one may have been in honor of Independence Day. There are stars and stripes in abundance (surely red, white, and blue), and a float in the background is draped with a banner that reads, in part, " . . . the nation." On the float in the foreground a sheaf of wheat is prominently displayed and children carry flags honoring Golden State counties: Alameda, Contra Costa, Colusa, Solano, Siskiyou, and others. A third float, visible on the right, carries women dressed in Grecian gowns. (Windsor Historical Society.)

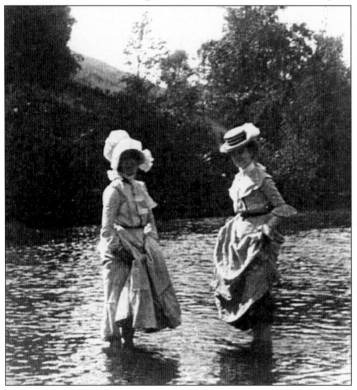

PRIM AND PROPER LADIES, EARLY 1900S. Forever cool on film, Vernie Washburn, right, and a friend wade in the Russian River. Dressed in stylish costumes of the day—high-collared, long-sleeved, ankle-length dresses with corsets and petticoats beneath—the ladies undoubtedly felt the heat intensely. (Windsor Historical Society.)

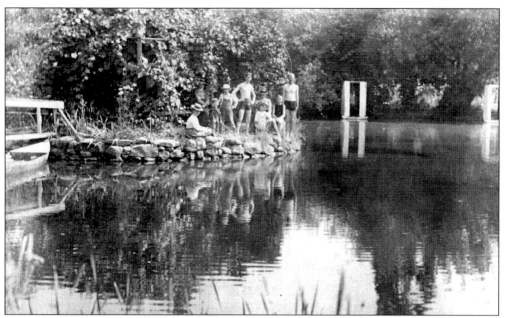

THE RICH FAMILY'S GLEN VALLEY SPRINGS RESORT, EARLY 1900S. Shown in this photograph are, from left to right, unidentified resort guests, Edwin Rich, Ella Faught Rich, Clarence Rich, and William Burr Rich, far right. Native Americans who lived in the area enjoyed the spring-fed lake long before the arrival of eastern pioneers. (Windsor Historical Society.)

ALL THAT JAZZ, 1929. Ballroom dancing was a popular activity in old Windsor. In the 1800s fraternal organizations built meeting halls that had ballrooms with high-quality dance floors, and civic groups cooperated in hosting dances. In addition, on the corner of Windsor Road and Windsor River Road, one of the town's earliest structures, the Philpott Building, had a beautiful bird's-eye maple dance floor. When the 1906 earthquake destroyed the upper level of the building, it was not reconstructed. (Windsor Historical Society.)

THE WINDSOR GRANGE

INVITES YOU TO A

JAZZ DANCE

AT I. O. O. F. HALL, WINDSOR

SATURDAY NIGHT

NOVEMBER 16th, 1929

————

SMITH'S NIGHT HAWKS

————

COUPLES $1.00

Extra Lady, 25 Cents

March 22 1895

Dear Sister Emma
I will write you
a letter.
to let you no how I
am getting a long
I am a going to School
my squirals is all alive
yet
I lead the gray
squirl with a chain
the red cow has
a calf
we are a gonto let
bander have the
spotted cow to mills
I shot a salmon
with the 22 this
winter
we have light
turkeys setting
one will hatch
next welab
is Ray going to
school yet

arthur Brooks

PET SQUIRRELS AND SHOOTING SALMON, 1895. Writing and receiving letters was a highlight of life for pioneers who had no other means to communicate with distant relatives. This rare and wonderful letter, penciled by 14-year-old Arthur Brooks to his older sister Emma, tells us much about early Windsor. It vividly captures the essence of life on an 1895 farm and, because it was written by a boy with a simple academic education, precisely conveys the way he and the people around him spoke. (Brooks family collection.)

A BARREL OF FUN, C. 1900. Cute as can be and creatively posed in a memorable snapshot, Catherine "Kate" Arata stands behind two friends who have squeezed into a rolled-oats barrel. (Arata family collection.)

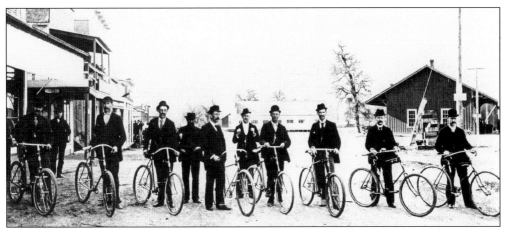

WHEELING IN WINDSOR, C. 1900. Between 1877 and 1902, bicycles were a popular means of personal transportation for adults, the first step forward from the horse and buggy. During this era, bicycle clubs were organized throughout the United States, and the men in this photograph were probably members of one such club. A Windsor old-timer recalls that his bicycle had a light that was fueled by "a mixture of carbide and water gas." Above, right, is the train depot. (Windsor Historical Society.)

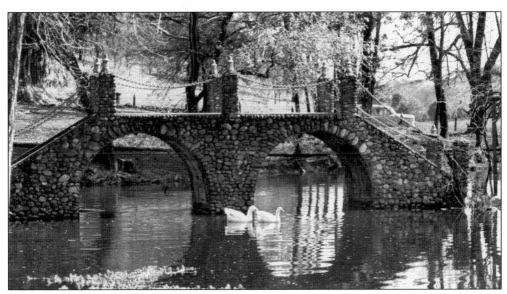

SPRING LAKE BRIDGE, BUILT IN 1919. This shaded glade was a popular picnic area for many years. The stone bridge with its elegant Roman arches was constructed by Gerardo Bossi at Spring Lake on Chalk Hill Road. In its prime, each bridge pillar was topped by a marine lamp. The bridge still stands, minus its lamps, but Spring Lake is now little more than a big puddle, having been drained when a deep well was drilled nearby. (Greeott family collection.)

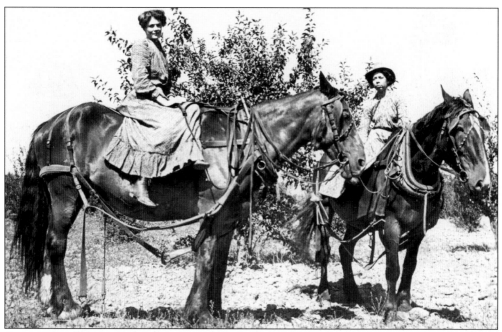

GIDDYUP! C. 1900. Margaret Davies, left, and Kate Arata, right, decided to ride the work horses back to the barn at the end of the day. Margaret, a San Francisco girl, sat sidesaddle in a ladylike manner, while Kate, a practical Windsor girl, sat securely astride her horse. (Arata family collection.)

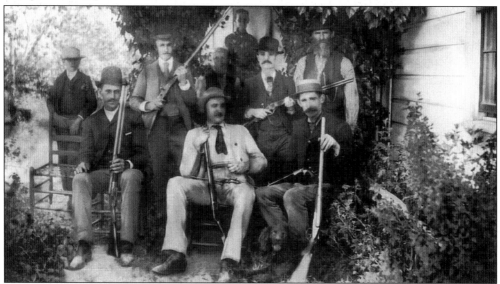

HUNTING PARTY, 1886. There was much wild game in early Windsor and hunting was a popular sport. This picture was taken at the McCutcheon home on Windsor River Road. Individuals are, from left to right, (seated in front row) James Bell McCutcheon Jr., an unidentified man, and William Hugh McCutcheon; (second row) an unidentified child, an unidentified man, James Bell McCutcheon Sr., George McCutcheon, and William Charles McCutcheon. Standing behind the men is James Mary Jane McCutcheon. (McCutchan family collection.)

DAYTRIPPING, EARLY 1900S. Before the Golden Gate Bridge was completed in 1937, travelers crossed San Francisco Bay in ferryboats. In this scene, Windsor daytrippers wait in Vallejo for a ferry. Standing on the left is Jack Arata with Margaret Davies, Minnie Davies is seated in the center, and Louis Arata is on the far right. (Arata family collection.)

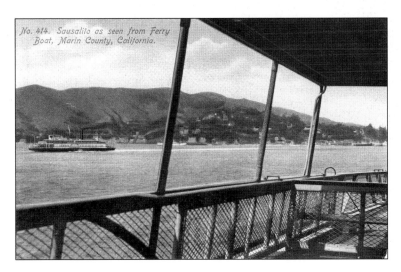

No. 414. Sausalito as seen from Ferry Boat, Marin County, California.

FERRYBOATS ON SAN FRANCISCO BAY, C. 1903. This postcard captures the sleek beauty of ferryboats during an era when crossing the bay was an exciting marine adventure. (Greeott family collection.)

99

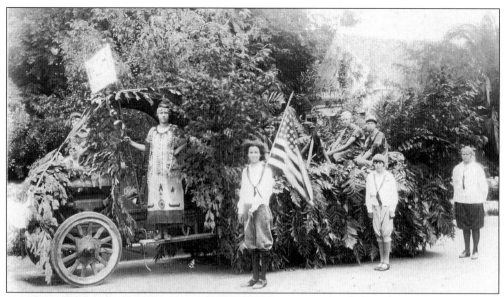

CAMP FIRE GIRLS PARADE FLOAT, c. 1925. On June 11, 1926, industrialist Leonard Howarth deeded land for a Camp Fire Girls camp on Chalk Hill Road to Windsor's Wa-Lo-Hi group, led by Mary M. Carter, who is standing on the running board in this picture. Each member of the group was also deeded a redwood tree on the property. In 1932, the deed to the camp was transferred to the Sonoma County Camp Fire Girls. The girl wearing a headband on the back of the float is Dorothy DuVander. (Windsor Historical Society.)

EXCITED YOUNG ACTRESSES, 1930. Shown here, best friends Lorraine Kimes, costumed as a Dutch girl, and Annie Mathis, wearing a Boy Scout uniform, can hardly wait to perform in their latest play at Soyotome School. (Kimes family collection.)

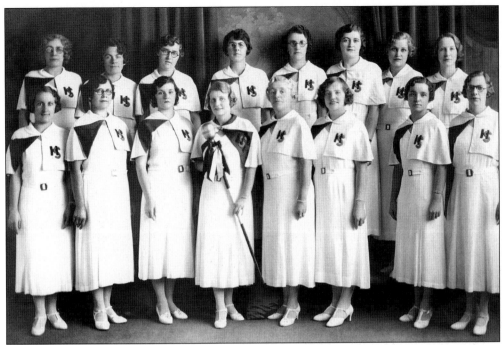

Sons of Hermann Choir, c. 1930. The choir group shown above was based in Santa Rosa but at least two of the singers were from Windsor. They are, fourth from the right in the front row, Bernice Basso (Rupp), and, third from the right in the back row, Libby Schwab. Libby's husband, Paul, was a musician and, like his wife, enjoyed singing, so they participated in many Bay Area German cultural events. Bernice Basso's mother and father, a beer maker, immigrated from Germany, lived in San Francisco, then bought a ranch on Gumview Road. The National Order of the Sons of Hermann is a German-American organization that promotes appreciation for the German language and preservation of German customs and traditions as well as provides insurance for its members. (Windsor Historical Society.)

Cool Hair, 1933. The marcel wave was all the rage in 1933. Usually, the hair was processed with curling irons heated on a burner, but this advertisement promises the style without the heat. (Author's collection.)

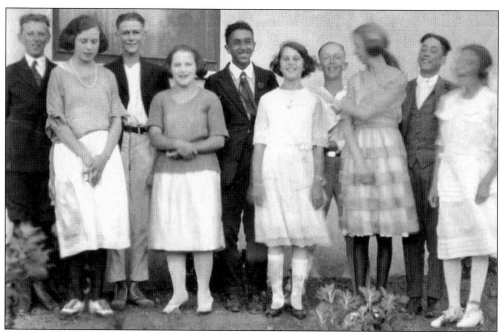

PARTY TIME, 1922. Filled with teenage enthusiasm, best friends, all about 13 years old, gathered at the home of twins Don and Dorothy DuVander to celebrate a special occasion. The teens are, from left to right, John Luebberke, Etta Hastings, Wendell Packwood, Ivy Rich, Vincent Cogliandro, Joan Harris, Don DuVander, Dorothy DuVander, Frank Frediani, and Margaret Russell. Windsor had no high school until recently, so most teens attended Healdsburg High School. (Windsor Historical Society.)

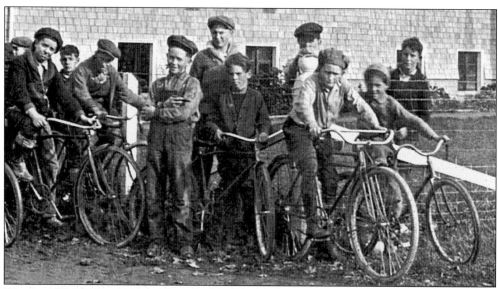

BOYS ON BICYCLES, 1920s. After World War I, America's economy boomed and companies such as Sears Roebuck and Montgomery Ward began producing inexpensive bicycles for youngsters. Every boy wanted a bike, enjoyed being with biking pals, and proudly posed for photographs. (Windsor Historical Society.)

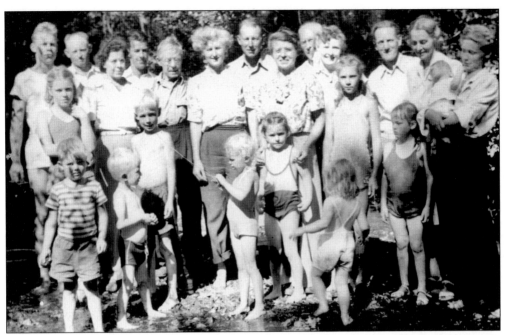

A Picnic at the Creek, c. 1945. A shady creek is an ideal picnic site. The shallow water is safe for little ones' play and the cool shade is a relief on hot summer days. Pictured above are, from left to right, (back row) Bill Beedie Jr., Jack Beedie, Isabelle Beedie, Doud McRoderick, ? Gladen, Bill ?, Lillian Beedie, Bill Beedie Sr., Ivy ?, El Freis, Lura Freis, and Peggy McDonald (holding Roderick). The children are Audrey Beedie, Leslie Beedie, David Johnson, Richard Johnson, Julie ? (in front of Gladys), Carol Ann Beedie (in front of Lillian), and Terry ? (in front of Ivy). (Windsor Historical Society.)

Placid Percheron, 1937. George Greeott had a way with ranch animals, which is evident in this snapshot in which he is reclining on the back of one of his retired Percherons, Chub. George respected his horses and the work they had done for him, so when Chub and his partner, Queen, reached the end of their working years, they lived a leisurely life of retirement, treated to good pasture and winter feeding in a warm barn until the end of their days. (Greeott family collection.)

ICE SKATING AT YOSEMITE, 1907. Like other affluent families, the Hotchkisses enjoyed vacations at popular resort areas. This action shot was taken as Hazel Hotchkiss and her brother Homer were helping Frances Skinner navigate the ice on Mirror Lake. (Hotchkiss family collection.)

TIJUANA TRIP, 1930s. Motorcycles, like the Harley Davidson shown above, provided inexpensive transportation for the adventurous, luring many to Mexico. Draped in serapes and wearing sombreros are cousins Chris Martin, left, and Ned Martin, right. (Windsor Historical Society.)

Nine

WINDSOR AND WAR

Windsor men defended their country in all major world conflicts, but during World War II, the community was uniquely impacted. An Army air base was built on Windsor's southern border, a prime military target that brought fear to the hearts of citizens as well as a 24-hour stream of noisy military vehicles and fighter planes that roared overhead, sometimes crashing nearby. In 1943, on the other side of town in a defunct migrant labor camp on the old Calhoun Ranch, the government established a prisoner-of-war camp for captured German soldiers. The POWs were transported by train to downtown Windsor, where they marched two miles to the camp on Windsor River Road.

WINDSOR'S PRISONER-OF-WAR CAMP, C. 1943. Among the German POW farm labor camps in California, satellites of Camp Beale, Windsor's was the first to open (August 1944) and the last to close (June 1946). Pictured above is Don Sullivan, who served 20 months at Camp Windsor. (Windsor Historical Society.)

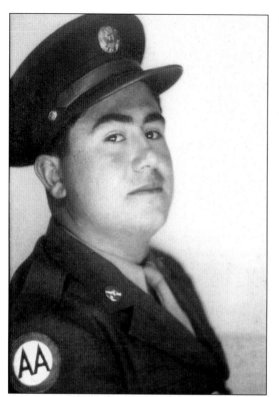

PVT. JOHN BERTOZZI, C. 1944. Drafted into the Army when he was a junior at Healdsburg High School, John was trained in combat intelligence and served during World War II with the 494th Anti-Aircraft at Utah Beach, Normandy, Northern France, and the Rhineland (Germany). He received three major battle stars. After the war ended, John, along with several other local boys who had sacrificed their secondary education to serve their country, returned to high school and graduated. (Bertozzi family collection.)

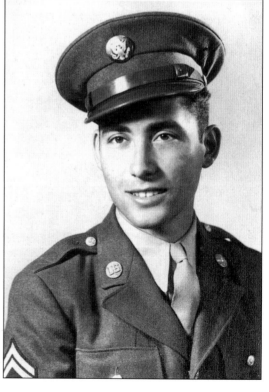

CORP. ALFRED BERTOZZI, C. 1944. Alfred, a radioman, had attained the rank of corporal at the time of his discharge from the Army following active duty in the Pacific Islands. Alfred is a cousin to brothers John, above, and Angelo, on the following page. (Bertozzi family collection.)

PFC Angelo Bertozzi, c. 1944.
Angelo was a member of the renowned
Merrill's Marauders, an Army Ranger-
type unit that responded to President
Roosevelt's call for volunteers for "a
dangerous and hazardous mission." The
Marauders, who suffered heavy
casualties, were under the direction of
Brig. Gen. Frank Merrill. A later
member of the Marauders, Angelo was
drafted into the unit and distinguished
himself in battle, receiving a combat
infantry badge and three major battle
stars. Angelo is the older brother of
John Bertozzi, pictured on page 106.
(Bertozzi family collection.)

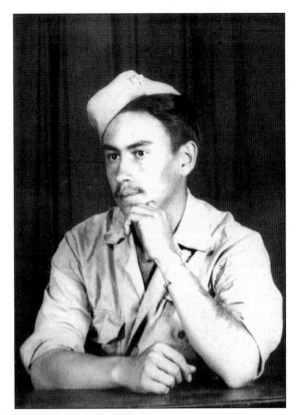

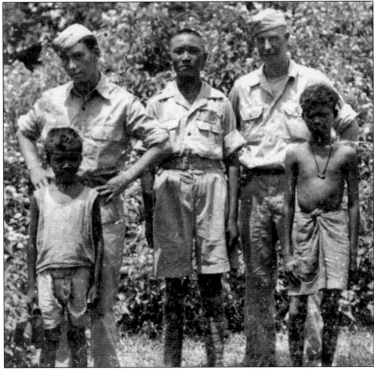

Combat Weary Officer, c. 1944.
Angelo Bertozzi,
pictured at left
while on duty in
India, also served in
Burma and was a
liaison officer to
China. The three
Bertozzis pictured
on pages 106 and
107 grew up on
Windsor's Wohler
Ranch. (Bertozzi
family collection.)

107

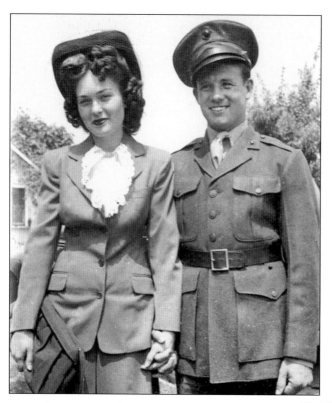

WARTIME MARRIAGE, 1943. Lovely Patricia "Patsy" Sutton met dashing Marine Donald Emery Camp in Southern California where he was stationed and she worked in a defense plant—one of the thousands of Rosie the Riveters who built warships, airplanes, tanks, and bombs. Like so many wartime romances, theirs was a whirlwind courtship that culminated in a simple wedding. After the war, the couple moved to Sonoma County, where Patsy had lived before, and eventually settled in Windsor. Pat worked at Fluor Corporation and Don worked in construction. (Author's collection.)

Remember Pearl Harbor!

'Twas on a peaceful Sabbath day
A ruthless enemy held sway
Without a single warning cry
A group of vultures from the sky
Spread destruction, fear and death
Maimed, destroyed by Satan's breath.

Americans, we can't forget
Until we've evened up that debt.
Each of us must do his part
We cannot sell our country short
For we must give our all—and more
To help and even up that score.

Let's give our dollars—they can fight
They'll help to crush the Axis might.
Let's fight together, on and on
Peace and Victory then shall dawn.
Remember and just give and give,
They died, my friends, that we might live.

By TONY CABOOCH
of Long Beach Federal Savings

★ ★ ★ ★ ★ ★ ★ ★ ★ ★ ★

REMEMBER PEARL HARBOR! Media, movies, and private businesses urged Americans to buy war bonds and contribute elsewhere to the war effort. The patriotic and emotionally charged card on the right was given to those attending Leuzinger High School graduation ceremonies in Inglewood, California, June 1942, and became a bittersweet memento for a Windsor family. (Author's collection.)

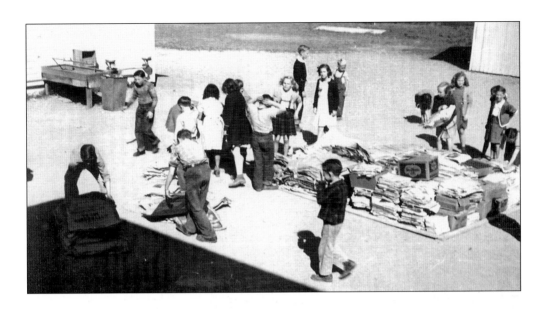

PAPER DRIVE, C. 1942. During World War II people of all ages did their part for America. Shown above are children collecting paper, and below, adults loading it for reprocessing. Citizens also collected tin cans, metal household containers, rags, kitchen fat, and even toothpaste tubes, which were made of lead and could be recycled into bullets. People sacrificed for the troops, accepting the rationing of cars, gasoline, tires, coffee, meat, sugar, cheese, canned food, butter, leather, clothing, and many other items. Adults invested in savings bonds, and children saved pennies for savings stamps, which in quantity could be converted to war bonds. Women baked, knitted socks and mittens, and wrote letters to men and women in the armed forces. (Windsor Historical Society.)

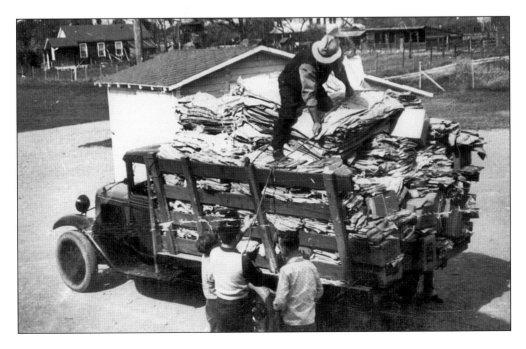

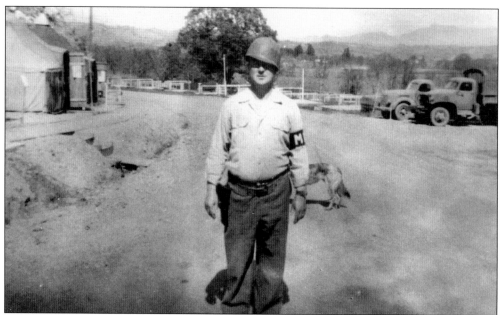

ON GUARD, C. 1944. Security at Camp Windsor was relaxed, consisting of four-foot high barbed wire fences, two low guard towers, and a single wood stockyard-style entry gate. Approximately 30 guards oversaw an average of 250 German POWs, sometimes more during the peak of harvest, and an unusual camaraderie existed between POWs and guards. One guard secreted a prisoner named Willi out of the camp for a movie in Santa Rosa. Another guard left his field post to visit a girlfriend and did not return at the end of the work day, so a POW gathered the guard's gear, including his rifle, and took them back to camp. (Windsor Historical Society.)

PRISONER COMPOUND. Located on roughly 70 acres of land, the prison compound was approximately 50 by 100 yards and both Army personnel and POWs were billeted in tents. There were also latrine tents and a large cook tent. Buildings included a laundry/bathhouse and a recreation hall, and there was enough open space for soccer. (Windsor Historical Society.)

PRISONERS READY FOR WORK. POWs harvested hops, grapes, and prunes, working nine-hour days Monday through Saturday. Each morning they lined up outside their compound where local farmers picked them up. Guards accompanied larger groups, but some smaller groups were trusted to work without guards. Camp Windsor was administered by three elements: the military commander and his staff; the managing agent for Sonoma Growers, Inc., Walter Rueger, who was fluent in German; and a designated POW "First Sergeant." (Windsor Historical Society.)

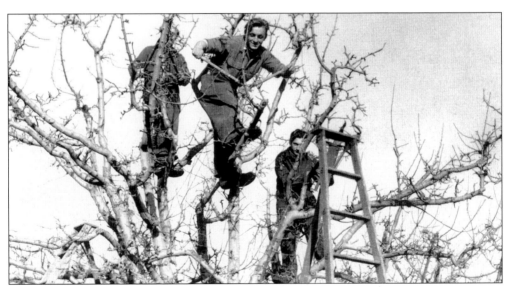

A GODSEND. Farmers from Windsor, Healdsburg, and Sebastopol employed Camp Windsor POWs, considering them a godsend while so many local young workers were overseas. The feeling was apparently mutual, for after the war many of the Germans wrote to Sonoma Grower's agent Walter Rueger seeking permission to come back. (Windsor Historical Society.)

HONORING THE ARMY AIR CORPS, C. 1942. During World War II when almost every family had one or more loved ones in military service, banners were hung on walls and in windows to honor the specific military branch in which their son or daughter served. Typical banners of the era were red, white, and blue with a gold fringe along the bottom. (Author's collection.)

WORLD WAR II KEEPSAKES. Servicemen and women kept a variety of souvenirs from areas in which they served. To the right are copies of currency collected during duty in China, Australia, New Zealand, and India—only a handful of the locales in which airmen were stationed. (Author's collection.)

SERVING IN THE WAR TO END ALL WARS, C. 1918. These World War I servicemen are, from left to right, Chet Robbins, ? Boyd, ? Redden, and Edwin Rich. (Windsor Historical Society.)

NATIONAL GUARD TRAINING, 1901. One can only imagine why the man in the center of the above scene is wearing women's clothing. Was it a practical joke, punishment for an infraction of the rules, or something more bizarre? We do know the National Guard trained at Glen Valley Springs on Chalk Hill Road and when push came to shove, the Guard was willing and able to serve and protect. (Windsor Historical Society.)

IN MEMORY OF HEROES, C. 1900. This Lady Liberty postcard illustrates the importance of Memorial Day in bygone eras. It was a day set aside to honor war dead with military parades. Families gathered at Shiloh and cemeteries to picnic, clean up gravesites, and decorate the final resting place of loved ones. The holiday originated in 1868 when Gen. John A. Logan, commander in chief of the Grand Army of the Republic (GAR), established Decoration Day to adorn the graves of Union soldiers. The name was eventually changed to Memorial Day and honors the dead of all wars. (Greeott family collection.)

Ten

TRAVELING FROM THERE TO HERE

Transportation changed dramatically during Windsor's first 100 years, from dusty trails and wagon teams to railroad tracks and trains, paved roadways and automobiles and, finally, airplanes. Mankind loves speed and each new innovation that moved us faster was exciting, each new vehicle a prized possession worthy of a snapshot. In every family album there are usually many pictures of family members standing beside their vehicles. Great-grandpa was as proud of his team of fast horses as a later generation's teen would be of his souped-up roadster.

WALKING TO THE BACK FORTY, EARLY 1900s. "Going afootback," as some old-timers referred to walking, was the most common way people got from here to there until recent times. Many pioneers had walked across the nation, so folks thought nothing of hoofing it to town, to school, to visit friends, or just to go for a leisurely stroll. In this photograph, Kate Arata (right) and a friend head out, perhaps to pick apples or wild blackberries. (Arata family collection.)

A Typical Sonoma County Road, c. 1900. The scenery was lovely but one had to put up with ruts, dust in summer, mud in winter, and unexpected critters both tame and wild. (Arata family collection.)

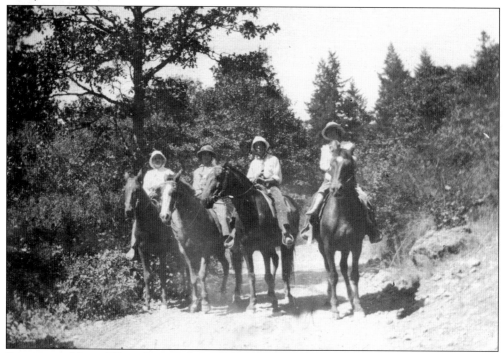

Riding on Mark West Springs Road, Early 1900s. Things have changed considerably since Kate Arata (second from right) and friends rode on this popular byway. (Arata family collection.)

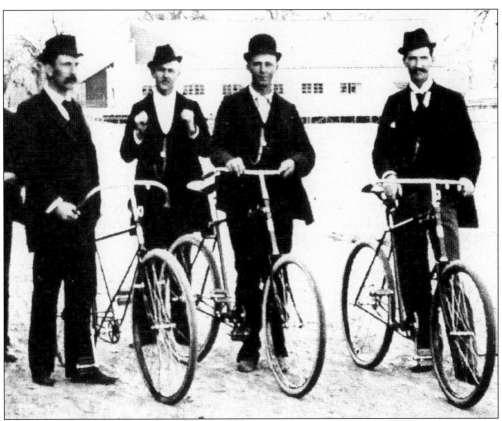

HANDLEBARS, C. 1900. Dressed to impress, these handlebar-mustachioed trendsetters posed for the camera before taking their speedy new bicycles for a spin. (Windsor Historical Society)

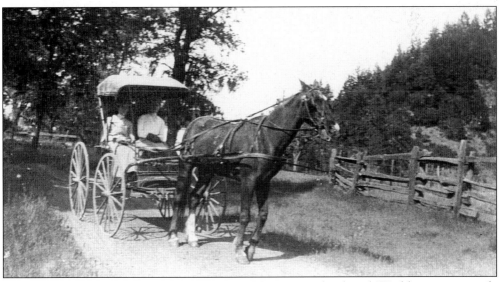

A TOPSY WITHOUT THE TURVY, EARLY 1900S. Traversing a local road, Washburn women rode comfortably in their horse-drawn vehicle, known as a Topsy. (Windsor Historical Society.)

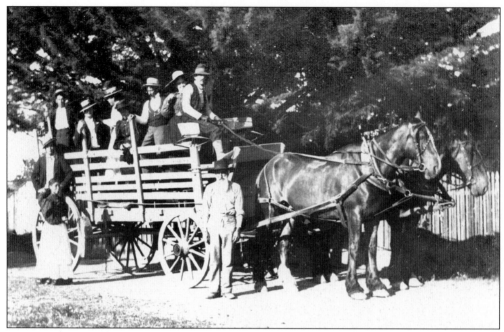

MOVING A CROWD, C. 1905. Transporting a group of ladies and gents required a large wagon and sturdy draft horses. Above, Benito Arata stands near the horses, Theresa Arata is near the rear of the wagon, and the driver is Louis Arata. (Arata family collection.)

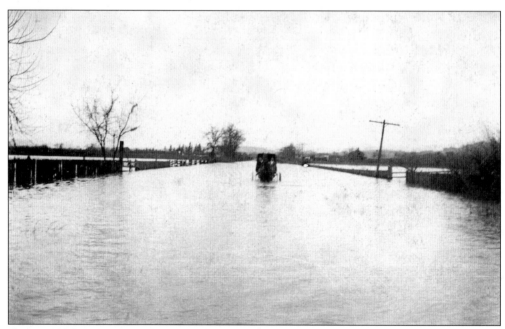

ONE OF MANY FLOODS, C. 1910. Sonoma County experienced many floods prior to the construction of Warm Springs Dam and extensive Russian River dredging. The photograph above shows a buggy navigating flood waters at Grant's Flats on old Highway 101. Flood days were always exciting for school children, who were forced to stay home and loved it. (Arata family collection.)

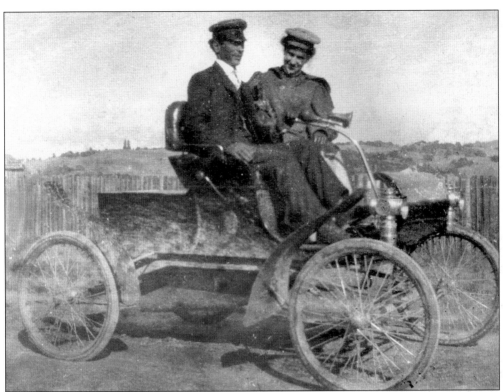

MERRY OLDSMOBILE, C. 1900.
In this photo, Jack Arata and
Anne Davies go for a ride in an
early curved-dash Oldsmobile. At
the time, most people were wary
of the new vehicles so horses
were Oldsmobile's competitors,
not other horseless carriages. The
cost of the 1900 Oldsmobile,
including mud guards, was $650.
(Arata family collection.)

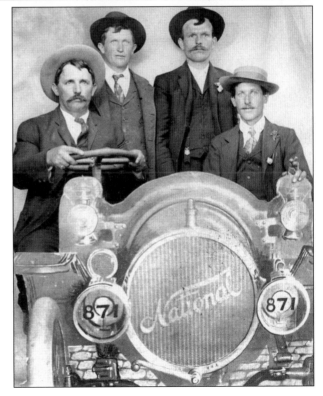

**NO LICENSE NEEDED, EARLY
1900S.** There weren't any
driver's licenses in those days, but
if there had been, John Greeott
wouldn't have needed one when
he took the wheel of a National
Automobile photography studio
prop. Passengers with John
Greeott are, from left to right,
Emilio Malano, Louie Pons, and
an unidentified friend. (Greeott
family collection.)

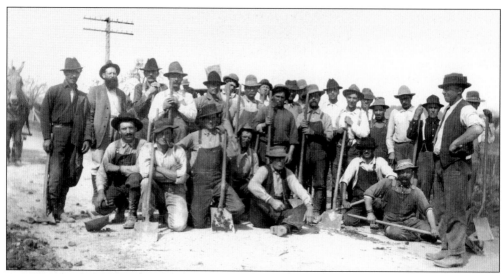

ROAD CREW, C. 1912. Many men wielding shovels and teams of 10 to 12 mules pulling massive equipment were needed to prepare the roadbed (now Old Redwood Highway) for paving at the turn of the last century. The workers shown above include John S. Beedie, William Beedie's father. (Windsor Historical Society.)

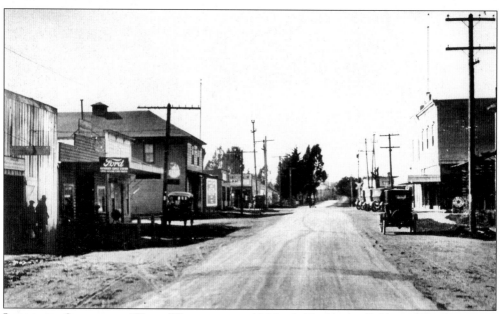

IMPROVED STREET IN WEST WINDSOR, C. 1930. A Ford sign (left) and Ford cars are prominent in this downtown scene, evidence of the growing popularity of low-priced Fords, which the Ford Motor Company began mass producing around 1913. The Model T Ford, introduced in 1908, could speed along at 40 miles per hour and travel 22 miles on a gallon of gasoline. By 1927 more than 15 million Model Ts had been manufactured. (Windsor Historical Society.)

MOTORCYCLE MAN, LATE 1920S. Tooling downtown, Bud "Toots" Martin paused by the ice cream parlor to have his picture taken. (Windsor Historical Society.)

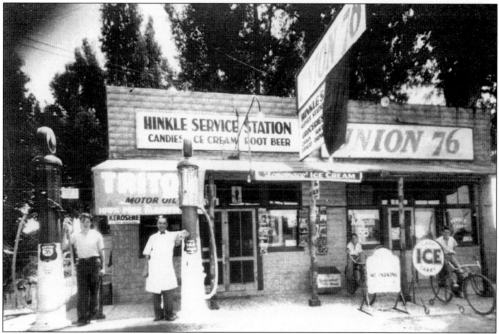

HINKLE SERVICE STATION, 1930S. John Edward Hinkle owned the Union Gas Station, was a barber, and also sold ice cream and other items. In those days, service included filling customers' gas tanks, cleaning windshields, and checking air in tires and oil levels. Individuals in this photo are, from left to right, Edward Hinkle, John Hinkle, and George Hinkle, and Sam Lawson on bicycles. (Windsor Historical Society.)

THE REDWOOD HIGHWAY, 1920S. During the 1920s, through the efforts of the Redwood Empire Association, Highway 101 from the Golden Gate Bridge to Josephine County, Oregon, was designated the Redwood Highway. The newly paved road made travel easy and comfortable. Shown above is the railroad overpass at Eastside Road and Old Redwood Highway with O.G. Wager's car in foreground. (Healdsburg Museum.)

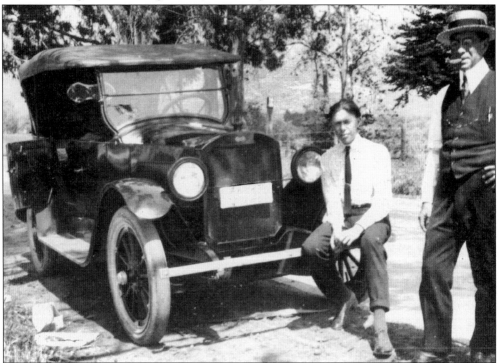

THE NEW CLEVELAND, 1930S. From left to right, Jimmy Crandall and August Arata pose with a Cleveland automobile. (Arata family collection.)

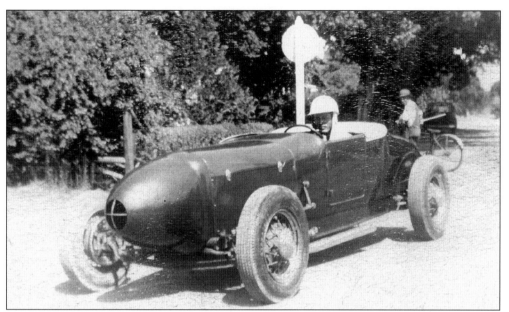

MODEL T ROADSTER RACE CAR, 1948. Ed Binggeli powered the 1927 roadster shown above with a 1941 Flathead V-8, and in 1948 on a sand track near Reno, Nevada, won the time trials with a speed of 119 miles per hour. Two months later he raced the car on the same track again, this time using alcohol fuel, and won the time trials with an average speed of 127.6 miles per hour. The aerodynamic front end of Bingelli's car was originally an airplane fuel tank. (Windsor Historical Society.)

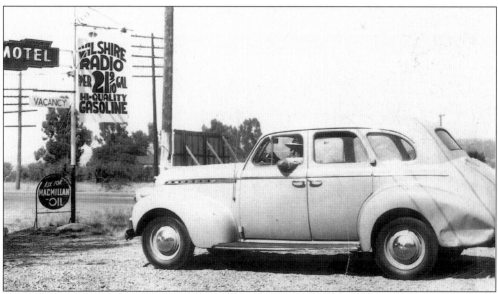

MOTELS AND CHEAP GAS, 1949. By mid-century, Americans were traveling in record numbers, and motels (also called motor courts and motor lodges), gas stations, and billboards dotted Highway 101 through Windsor. (Windsor Historical Society.)

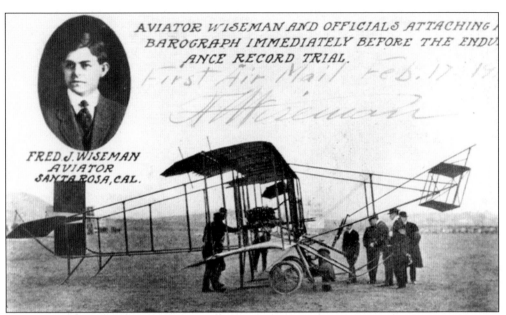

THE WORLD'S FIRST AIRMAIL SERVICE, 1911. On February 13, 1911, several hundred people gathered on Windsor's Laughlin Ranch to witness the maiden flight of an airplane that had been secretly built in one of the ranch barns. After the successful test flight, pilot Fred Wiseman dismantled the airplane and shipped it to Petaluma where it was reassembled on the Sonoma-Marin fairgrounds. Wiseman then flew to Santa Rosa, delivering to the city's mayor a stamped and canceled letter from the mayor of Petaluma, thereby establishing the world's first airmail service. Wiseman's airplane is now preserved in the Smithsonian Institution in Washington, D.C. (Healdsburg Museum.)

CHOOSE AVIATION! The sky was the limit by the 1920s when the American School of Aviation placed this ad in a popular magazine. The school was seeking "red-blooded, daring he-men" for jobs in the growing aviation industry, "the greatest venture since time began." (Author's collection.)

FAREWELL! C. 1900. Pictured above in a horse-drawn buggy, members of the Arata family leave the ranch, heading down their dusty lane toward town. The ladies are dressed in fine feathered hats and there is luggage in the back of the wagon, which suggests they're probably going to the train depot. (Arata family collection.)

REAL ESTATE BARGAINS, 1900. At the turn of the century, a man could buy a large ranch for a few hundred dollars, and for many decades thereafter, Windsor properties were available at bargain prices. Wouldn't those old-timers be surprised if they visited their hometown today? (*Windsor Herald*, January 1900.)

BIBLIOGRAPHY

Alley, Bowen & Co. *History of Sonoma County*. San Francisco: 1880. Higginson Book Co. Salem, 1984.

Beedie, William L. *Windsor History and Happenings*. Windsor: Windsor Smithy Press, 1978.

Brown, Douglas. *German Prisoners of War in Northern California During WW2: The Story of the Camp Beale Prisoner of War Camp and its Satellite Farm Labor Branch Camps*. Penryn: 2003.

Carter, Tom. *First Lady of Tennis: Hazel Hotchkiss Wightman*. Berkeley: Creative Arts Book Company, 2001.

Engdahl, Jane M. *The Project Windsor Report*.

LeBaron, Gaye and Joann Mitchell. *Santa Rosa, A Twentieth Century Town*. Historia, Ltd., 1993

Wilson, Simone. *Sonoma County, the River of Time*. Chatsworth: Windsor Publications, 1990.

Thos. H. Thompson & Co. *New Historical Atlas of Sonoma County*. Oakland: 1877.

Reynolds & Proctor. *Illustrated Atlas of Sonoma County. Santa Rosa, 1897*. Mt. Vernon: Windmill, 1998.

Windsor Community Methodist Church. *Windsor Community Methodist Church 1863–1963*.

SURNAME INDEX